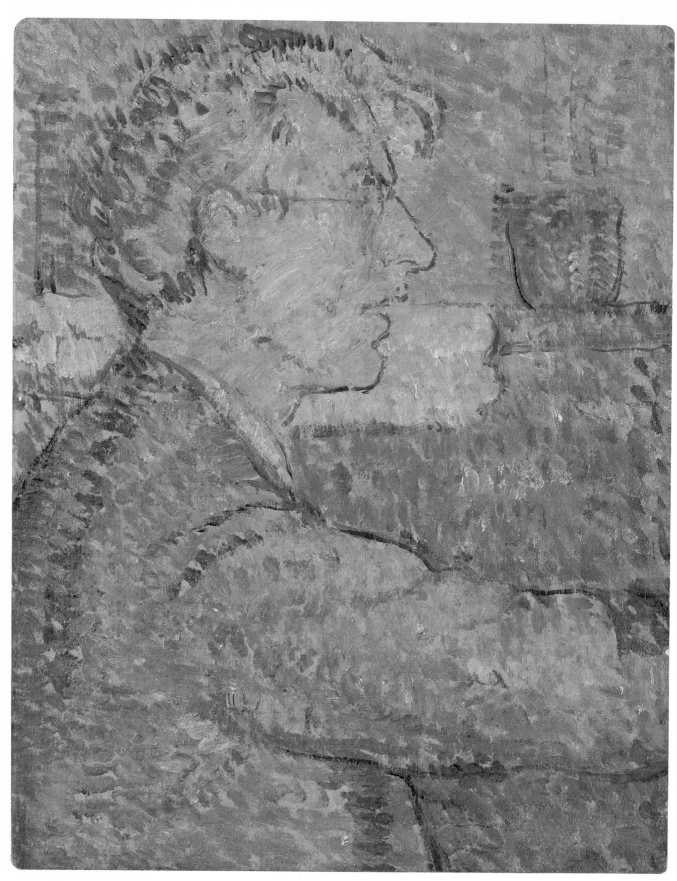

2 Vanessa Bell *Roger Fry* 1912

The OMEGA WORKSHOPS

Alliance and Enmity in English Art
1911 – 1920

Anthony d'Offay Gallery

Anthony d'Offay
9 and 23 Dering Street
New Bond Street
London W1

Exhibition dates
18 January to 6 March 1984

cover: *Colour Samples of the Six
Omega Linens* 1913 (no 130)

© 1984 Anthony d'Offay
ISBN 0 947564 00 4
Exhibition co-ordinated by Judy Adam
Photography by Prudence Cuming Associates
Catalogue designed by Simon Rendall
Printed by The Hillingdon Press

PREFACE

This exhibition owes its genesis to the enthusiasm and generosity of Roger Fry's daughter, Pamela Diamand, and to Angelica Garnett, the daughter of Duncan Grant and Vanessa Bell.

Roger Fry founded the Omega Workshops in 1913 and Pamela Diamand vividly remembers visits there during her schooldays (the exhibition includes a box (126) decorated by her at the age of fourteen). We are particularly grateful to her for the childhood reminiscences she has contributed to this catalogue. Angelica Garnett was born in 1919, the year that the Omega finally closed its doors; but she was brought up in Charleston, the farmhouse on the Sussex Downs, near Lewes, where Duncan Grant and Vanessa Bell lived from 1916. Its decorations, furniture, pottery, lamps, rugs, textiles and so forth, whether made before or after 1919, were all conceived in the spirit of the Omega.

The story of how the Omega opened in 1913, how Wyndham Lewis and the Vorticists quarrelled with Fry and set up the rival Rebel Art Centre, is described in Judith Collins' newly published book *The Omega Workshops*. Therefore it need not be repeated here. The development of Omega design into the Twenties and Thirties is included in the Crafts Council's Omega exhibition which runs concurrently with this one. We have chosen rather to reduce the time span covered in our show in order to explore the art historical background to this extraordinary movement, which brought together in a single enterprise artists as temperamentally and stylistically different as Duncan Grant and Wyndham Lewis, Roger Fry and Gaudier-Brzeska.

Though their liaison was short-lived, all were apparently prepared initially to subordinate their individuality to the enterprise. No one knows exactly what happened to start the inevitable quarrel (over the decoration of a room at the Ideal Home Exhibition of 1913). Certainly there was something of a power struggle between Lewis and Fry. Those who broke away thought there had been sharp practice on the part of the latter. Although economics were an important aspect of the Omega, one suspects that at the root of it were moral, and above all, in a different sense, ideological differences. The joy in decoration for its own sake, the unworried insouciance of the less revolutionary and economically hard-pressed Bloomsburys, clearly got the goat of the radically idealistic Vorticists-to-be – in particular Wyndham Lewis and Gaudier-Brzeska, who were trying to create a new British art movement which would be the best in the world, regardless of what was happening anywhere else. Thus the two paths diverged and so far have not met again this century.

It could be that in that headlong decade, which almost seemed to speed up as the First World War approached, there were simply too many art groups and events jostling one another for recognition for any proper economic development to take place. However, there clearly was a demand for what was going on,

as is demonstrated by the Omega's survival through the war. All through the first years of the century, lacking any sophisticated commercial gallery support, artists banded together into an astonishing number of cliques, coteries and exhibiting societies. It was a necessary financial strategy. One must not however disregard the fact that, as with any new art, everybody wanted to see it, and at this time new foreign art was shown in Britain and British art went abroad.

Roger Fry was the driving force, the galvanic personality and the dedicated publicist behind a number of these enterprises and there obviously was general approval among the young avant-garde for his brave idea of a place where artists could work together producing ceramics, fabrics, screens, rugs and furniture designed in a modern spirit. That it should be a meeting place for ideas and a support to the artists by paying them seven and sixpence a day were integral to his conception. Of course it was not an entirely new idea in that one could find historical precedents in the Arts and Crafts Movement, and the ideas of William Morris. Conceived in a related spirit, the Borough Polytechnic Murals on which Grant and Etchells collaborated in 1911, show the more serious activity of the decade. The decorations for Madame Strindberg's Cabaret Theatre Club (The Cave of the Golden Calf) executed by Gore, Lewis, Ginner, Epstein and Gill demonstrate another side: the frenetic atmosphere of gaiety of the time. Within and without the art world the emphasis was on revelry. However, there was one crucial difference of approach between that of Lewis on the one hand and Gore, Grant and Bell on the other, and that was that the first saw something more precarious, sinister beneath it all, dangerous forces at work, whereas the latter saw what they were doing rather as a 'design for living'.

The important thing about the Omega common to all members was that it attacked bourgeois preconceptions about decorative art and furnishings. It attacked the idea that these should be as well-finished as if made by a machine, durable and expensive. The Omega's code of anonymity also undermined the idea of making personal masterpieces, just as it disregarded the idea of traditional materials in making furniture and the subordination of decoration to form. It was not unserious but it was essentially fun.

And, although they attacked bourgeois notions of good decoration (as well as good art), Omega productions were never conceived an example to the masses like their successors in the Bauhaus or de Stijl. Omega did not propose an art made for the people but more an art which they could make themselves. If it was for a new notion of morality, it proposed freedom from convention, not membership of a Utopian society. Nevertheless it is possible that the effects of the Omega were just as far reaching as their European counterparts – for coming out of a way of life which is a specifically British aspiration, appealing insidiously to British interests in the amateur. It seems that Roger Fry and Omega did create the basis for a kind of arty intellectual living in Britain which has affected every class of society since.

The primary and most interesting aspect of the Omega was in bringing art and life closer together, it helped to initiate acceptance of the idea that every

side of an artist's work is relevant to the whole, and must be taken into consideration. Yet for some strange reason, although it could encompass attitudes as different as Grant's or Bell's on the one hand, with their interest in decoration and Fry's on the other whose interest in form was almost a religion, it could not also encompass an iconography of morality, however unconventional, which was an important concern for Wyndham Lewis. The hedonism of the past which inspired Fry, Grant and Bell proved incompatible with Lewis's darker view of the future.

In many ways this exhibition is designed to complement *Abstract Art in England 1913-1915* – the Vorticist show we put together in 1969, which attempted to piece together part of the story of English Art at the time of the First World War. This is not the place to lament the loss of so many important art works from that period, suffice it to say that it has taken a number of years (and luck, chance etc) to assemble the show. One day the whole story will be told in terms of a great exhibition. In the meantime we would like to record our grateful thanks to Judith Collins and Richard Shone who have both lent their considerable scholarship to the exhibition and to all those who have helped to make the present undertaking possible. In particular we must mention Helena Aldiss, Ronald Alley, Dr and Mrs Igor Anrep, Isabelle Anscombe, Elizabeth Aslin, Robert Baty, Professor and Mrs Quentin Bell, Dr Margaret Bennett, Natalie Bevan, John Booth, Alan Bowness, Noel Carrington, The Charleston Trust, Annabel Cole, Richard Cork, Henrietta Couper, Prudence Cuming, The Crafts Council, Paul Drescher, David and Duncan Drown, Bryan Ferry, Norman Flynn, Deborah Gage, Fanny Garnett, Nerissa Garnett, Gilbert and George, Glasgow Art Gallery & Museum, Griselda Gilroy, Frederick Gore, Howard Grey, George and Christopher Harrap, Bila Harris, Carol Hogben, Julian Hartnoll, Nick Hawker, Dr Michael Kauffmann, Dan Klein, Mrs Tangye Lean, Elizabeth Lydiate, Jonathan Mason, Fiona MacCarthy, Walter Michel, Andrew McIntosh Patrick, Richard Morphet, Omar Pound, Simon Rendall, Professor Kenneth Rowntree, Clarissa Roche, Paul Roche, Hans Roeder, Simon Sainsbury, Alexander Schouvaloff, Frances Spalding, Philip Stevens, Sir Roy Strong, Betty Taber, The Trustees of the Tate Gallery, The Theatre Museum, David Thomson, Peter Thornton, Ralph Turner, The Victoria & Albert Museum, Dennis Vinall, Clive Wainwright, Sarah Walden, Simon Watney and Douglas Woolf.

Anthony d'Offay

RECOLLECTIONS OF THE OMEGA

The summer of 1911 was a specially hot one and taking advantage of the fine weather, my father, Roger Fry, commissioned his friends Duncan Grant and Henri Doucet, the French painter, to paint my portrait sitting by the pond in our garden at Guildford, but the plan got off to a very bad start because for two or three days Duncan never turned up. At last one evening he walked up the drive. In answer to the many enquiries he simply said he couldn't find the one shilling and sixpence for the fare. Eventually, he remembered a florin at the back of a drawer and came.

This episode must have been more significant than it would have seemed at first, for not long afterwards plans began for a joint decorative undertaking to employ the new generation of artists who had few prospects of selling their work.

So the sittings began in earnest and I sat for what seemed like days and days by the edge of the pond, my back aching and my legs stiffening, and failing altogether to respond to Doucet's entreaties to smile; 'Ah, elle ne sourit plus' he would moan . . . I was only nine. But the pond remained; dark and mysterious with flashes of red gold-fish beneath the surface and lily-pads basking flat in the sun; all this background was brilliantly interpreted by Duncan Grant in his portrait of me (42) – incidentally in a more comfortable pose. Later, when at work at the Omega, still intrigued by the pond-scape, he began an abstract picture of it. Roger was watching him and seeing the pots of hot size paint beside him, suddenly urged him to take the pots and pour the colour straight onto the design. 'Thus' said Duncan to me about seventy years later 'the first action-painting was born'. I went on to ask Duncan what it was like working at the Omega; 'Oh happy' he said, 'Very happy all the time'.

Another feature of the garden which played a big role in the work of the Omega was Roger's favourite globe artichoke plants that were grown both for food and beauty – especially beauty. Tall and stately with their grey, spikey leaves and great purple heads they were constantly woven into designs and became almost the leit-motif of the Omega.

Two years later in 1913, my brother and I were taken to London to witness the opening of the Omega Workshops in Fitzroy Square. What I remember most clearly was Henri Doucet standing at a trestle table with a length of crêpe de chine, which he was painting for a dress ordered by Lady Diana Manners. What a dress it must have been, glowing with peacock colours, violets, blues and greens, with languid ladies desporting themselves in idyllic scenery! It impressed itself so clearly on my mind I can still see it today. There were other brilliant and vivid things, especially Wyndham Lewis's screen with acrobats.

On another occasion we were taken to London to see the historic Omega room at the Ideal Home Exhibition at Olympia. I remember the general aspect,

8

the rather purple colour scheme and May Leighton's graceful painted dress. The artists had been able to paint on materials without that dreadful stiffening that usually accompanied hand-painted materials. I rather think the famous carved mantelpiece supports were there too. In the stand next-door was a grand piano and a musician paid to play the Moonlight Sonata all day long to the intense exasperation of Roger. What really took my childish fancy were the Russian mujiks sitting outside their huts carving figures and animals with an unbelievable skill and rapidity. I bought one and treasured it for many years.

When I went away to school my visits to the Omega were limited to holidays, but were frequent enough for me to keep up with what was going on. I was usually put in the care of Winnie Gill. She used to purvey a bit of gossip: such things as how, when she was taking a rest on a spare bed upstairs after a very exhausting session of ceiling decoration, Wyndham Lewis, thinking the room empty, came in swaggering with a new black and white checked cloth cap, strutting and posturing in front of the mirror, saluting himself and trying it on this way and that. She had lain low, hidden under the blanket, dreading what he might do to anyone who had witnessed this demonstration. Another time she mimicked Lady Ottoline's drawling voice, as she chose a hat and trimming for her reluctant daughter.

Of all the things at the Omega I found the pottery most inspiring and I well remember being allowed to accompany my father on one of his week-end trips to Poole Pottery, staying in friendly but very humble lodgings. We spent the days in the pottery, where the girls wedged the clay for him and turned the huge fly-wheel (no electric wheels then). He was finishing off the prototypes for the Omega dinner set and working out the construction of the very ingenious handles. He was already a very proficient potter, undaunted by such major pieces as soup tureens. All day we had, as companion, the old worker who finished off the castings of the large figures of dairy-maids and cows for the shop windows of dairies (one of my favourite sights of the high streets of those days). He worked all week-ends because he was so unhappy away from the pottery. This experience and the visit to the earlier Mitcham Pottery convinced me that making pottery was the nearest man can get to Heaven in this life. At about this time the Omega exported a lot of pottery to Scandinavia where it was much appreciated and must have had some influence on the excellent ceramics in those countries.

Roger was very pleased with the direction the Omega had taken, and felt that the fanciful shapes and fast-moving rhythms were altogether appropriate to their purpose. What changed this mood I do not know but in 1916 Roger Fry wrote from Paris that Picasso and all the other artists were thinking of Seurat more than of Cézanne. By 1918 Roger had begun to admire Ingres and to write about him. Thenceforward the contour ceased to be an integral part of his designs; it had become a skin enclosing something solid. The colours and shapes no longer danced on the canvas, for the approaching thud of the heavy feet of Picasso's elephantine women might be heard by those who kept their ear

to the ground. 'La Forme' was the new goddess in Paris and a very exacting one she was, pointing a plump finger towards 'Art Deco'.

About this time, Roger took me to a party given for the Russian Ballet. He wore the exotic pyjamas shown in this exhibition (133). Teddy Wolfe, who had been introduced to the Omega by Nina Hamnett, came in a costume borrowed from the Ballet which inspired him to dance with abandon. Shortly before he died, Teddy expressed his gratitude to Roger by saying that the experience of joining the Omega had enriched his whole life. 'I feel I owe Roger a great debt', he said, 'He introduced me to Arnold Bennett and all my Bloomsbury friends. He was always prepared for the most unexpected person to be as creative as he was'.

Just as I left school, the Omega closed down, but for a short time I worked there with Edward Wolfe and was given the job of painting lampshades, boxes and even decorating a children's garden tent. In 1920 the Omega held a clearance sale. Sadly it was over. It had taken seven years of Roger Fry's life but he did not look back. However, the Omega deserves to be remembered with gratitude – for its vigour and happiness, and for the delight in art it brought into everyday life.

Pamela Diamand

CHRONOLOGY by Judith Collins

1910

5 October– 31 December	Manet and the Post-Impressionists exhibition, Grafton Galleries
Winter	Duncan Grant begins murals for J. M. Keynes's rooms in Webb's Court, King's College, Cambridge

1911

February	Roger Fry asked by the House Committee of the Borough Polytechnic, Southwark, to provide mural decorations for the students' dining room
Spring	Grant visits Tunis and Sicily to look at Byzantine mosaics
April	Clive and Vanessa Bell with Roger Fry visit Turkey to look at Byzantine mosaics
July	Preliminary drawings by Eric Gill for the commission by Roger Fry to carve a large stone statue for the garden of his home Durbins, on the outskirts of Guildford
August	Borough Polytechnic murals undertaken by Fry, Grant, Bernard Adeney, Frederick Etchells, Macdonald Gill and Albert Rutherston
November	Paintings by Cézanne and Gauguin, Stafford Gallery. Spencer Gore paints *Gauguins and Connoisseurs at the Stafford Gallery*
December	Second Camden Town Group exhibition, Carfax Gallery Grant shows a work as a member of the group

1912

February	Fry forms the Mill Street Group in order to execute a joint entry in a Mural Decoration Competition advertised in *The Times*. Members are Grant, Frederick Etchells and Wyndham Lewis
10-24 February	Friday Club exhibition, Alpine Club Gallery. Exhibitors include Vanessa Bell, Frederick Etchells, Winifred Gill, Fry, Grant and Edward Wadsworth. Bell shows *Design for a Screen* (1) and *Roger Fry* (2)
March	Edward Wadsworth, C. R. W. Nevinson, Adrian Allinson and Mark Gertler paint mural panels for the Petit Savoyard restaurant, Greek Street
Spring	Jane Harrison, friend of Fry and principal of Newnham College, Cambridge, commissions Grant, and others to provide sketches for a mural scheme for the college

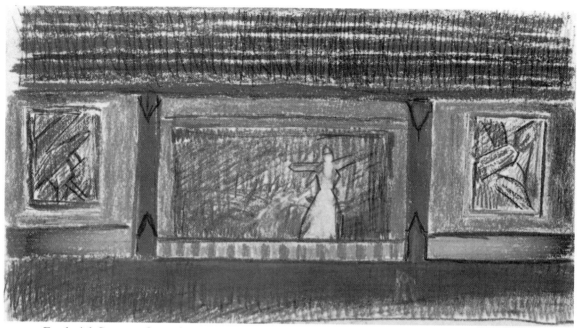

41 Frederick Spencer Gore *Study for Decorations in the Cabaret Theatre Club* 1912

April-May 1912	Grant and Frederick Etchells paint a mural of a street accident in a ground floor room at 38 Brunswick Square
1-15 May	Fry organises Quelques Independants Anglais exhibition at the Galerie Barbazanges, Paris. Exhibitors include Vanessa Bell, Frederick Etchells, Fry, Charles Ginner, Grant, Spencer Gore, and Wyndham Lewis
26 June	Madame Frida Strindberg's Cabaret Theatre Club opens at 9 Heddon Street, off Regent Street. The central room of the Club, named the Cave of the Golden Calf, contains a gilded sculpture of a calf by Eric Gill, totemic columns of humans and animals by Jacob Epstein, a mural on the subject of *Deer-hunting* by Spencer Gore, *Tiger-hunting, Birds and Indians,* and *Chasing Monkeys* by Charles Ginner, murals, screens and a drop curtain for the cabaret stage by Wyndham Lewis (see nos 37-41 and 86)
June	Grant paints a mural of a mixed doubles tennis match in a first floor room at 38 Brunswick Square
July	Fifth London Salon of the Allied Artists' Association Exhibitors include Bell, Fry, Gore and Lewis
5 October- 31 December	Fry's Second Post-Impressionist Exhibition, Grafton Galleries English exhibitors include Bell, Frederick and Jessie Etchells, Fry, Gill, Gore, Grant and Lewis. When the exhibition is rehung for the month of January 1913, Cuthbert Hamilton, Edward Wadsworth and Henri Doucet are included

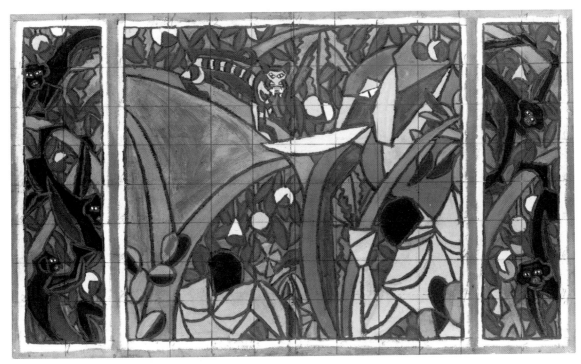

38 Charles Ginner *Design for Tiger-hunting Mural in the Cabaret Theatre Club* 1912

Winter	Grant and Bell together begin decorating boxes and other small domestic items
December	Fry writes a circular letter to colleagues to ask for financial support for his artistic design workshops which he is about to establish. The name Omega Workshops is mentioned for the first time. Fry also writes to Wyndham Lewis about *our* decorative scheme, implying that Lewis has an important status in the inception of the workshops

1913

24 January– 11 February	Friday Club exhibition, Alpine Club Gallery. Exhibitors include Wadsworth. Fry, Bell and Grant do not show
15 February– 8 March	Fry sends a selection from his Second Post-Impressionist Exhibition to the Sandon Studios, Liverpool. Artists included are Fry, Bell, Grant, Frederick and Jessie Etchells, Doucet, Hamilton, Wadsworth and Gore. Lewis is not included
February	Fry reaches his goal of £1,500 with money from colleagues to form the capital for the Omega Workshops Eric Gill and his wife received into the Catholic Church on 22 February. They spend the weekend walking over the South Downs with Leonard and Virginia Woolf

13

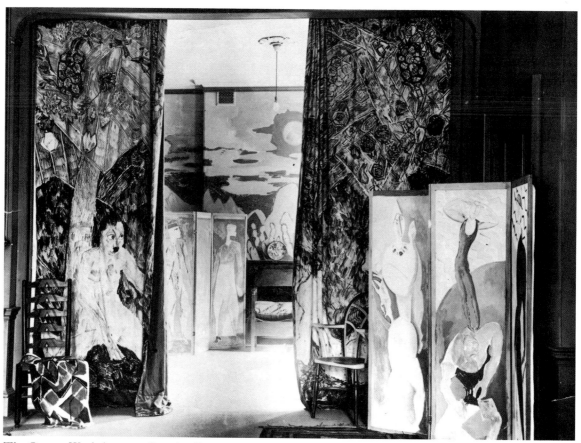

The Omega Workshops on Opening Day

15-31 March 1913	First Grafton Group exhibition, Alpine Club Gallery. The five Grafton Group members are Bell, Etchells, Fry, Grant and Lewis. Invited artists include Jessie Etchells, Winifred Gill, Gore, Hamilton, Wadsworth, Kandinsky and Max Weber. With the exception of the two foreign artists, Fry gathers together the core of artists who will work at the Omega Workshops in the summer. Painted screens and embroidered chair covers are shown alongside the paintings
March	Fry takes the lease of 33 Fitzroy Square as the base for the Omega Workshops
14 May	The Omega Workshops registered as a limited company
May	Omega Linens are printed by the Maromme Print Works, Rouen, France
June	Bell, Grant and Doucet paint murals on the showroom walls at 33 Fitzroy Square. Grant and Doucet paint the curtains which divide the two showrooms

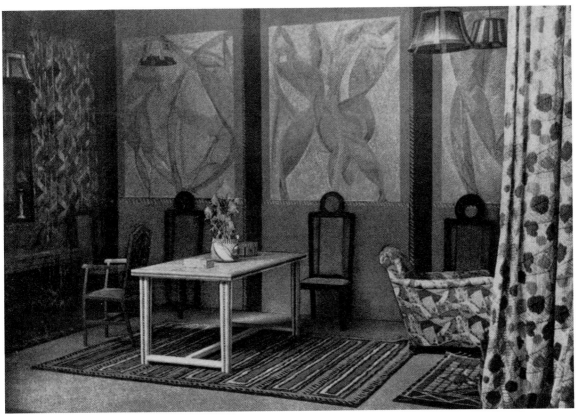

Omega Sitting Room at the Ideal Home Exhibition, October 1913

7-30 July	Sixth London Salon of the Allied Artists Association Exhibitors include Fry, Doucet, Gore, Gaudier-Brzeska, Kandinsky, Lewis, Wadsworth, and the Omega Workshops. Bell and Grant do not show
8 July	Press and preview day at the Omega Workshops
July	Two representatives from the *Daily Mail* separately contact Gore and Fry about the decoration of a room for the forthcoming Ideal Home Exhibition at Olympia
August	Bell, Fry and Grant paint mural panels for the Ideal Home Exhibition room
September	Bell and Grant paint canvas panels for the decoration of the exterior niches on the first floor of the Omega showrooms
5 October	Lewis walks out of the Omega Workshops after a row with Fry over the decorations for the Ideal Home Exhibition room. Wadsworth, Hamilton and Etchells leave with him
9-23 October	Omega sitting room at the Ideal Home Exhibition

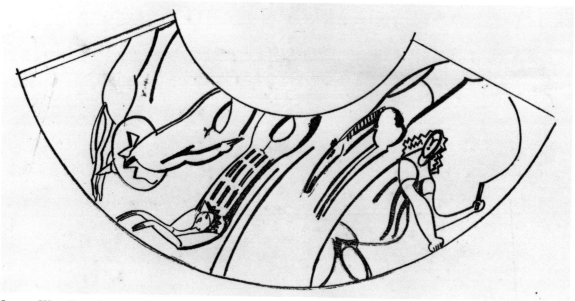

89 Wyndham Lewis *Design for Omega Lampshade* 1913

10 October 1913	Lewis sends a 'Round Robin' letter, signed by himself, Etchells, Wadsworth and Hamilton to supporters of the Omega, criticising the organisation of the Workshops and the work produced there
12 October– 11 January 1914	Post-Impressionist and Futurist exhibition, Doré Galleries, organised by Frank Rutter. Exhibitors include Etchells, Lewis, Wadsworth, Hamilton, Doucet, Gore and Ginner. Fry, Bell and Grant are not included
November– 14 January 1914	English Post-Impressionists, Cubists and Others exhibition at the Public Art Galleries, Brighton. Exhibitors include Frederick and Jessie Etchells, Lewis, Hamilton and Wadsworth. Fry, Bell and Grant are not included. Lewis writes a preface for the catalogue 'The Cubist Room'
December	Special Christmas exhibition at the Omega Workshops, which centres upon three rooms – an 'Ideal Nursery', a sitting room and a bedroom

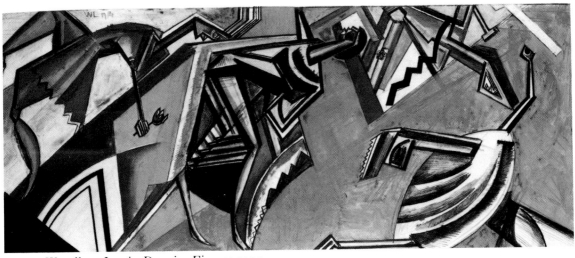

91 Wyndham Lewis *Dancing Figures* 1914

1914

January	Second Grafton Group exhibition, Alpine Club Gallery. Grafton Group now reduced to Fry, Bell and Grant. Invited artists include Gaudier-Brzeska, Winifred Gill, William Roberts and Nina Hamnett, all new members of the Omega Workshops, with the exception of Miss Gill who joined in the summer of 1913
13 February	Liquidation sale of the assets of the Cabaret Theatre Club. Madame Strindberg is thought to have taken the murals by Gore, Ginner and Lewis to America with her
25 February	Modern German Art exhibition, Twenty-One Gallery, including work by Kandinsky, Kirchner, Marc and Pechstein (also included are Bomberg and Wadsworth). Wyndham Lewis writes the catalogue introduction
26 February	Wyndham Lewis's decorations for the dining-room of the Countess of Drogheda, 40 Wilton Crescent, are unveiled, along with a small exhibition of his recent work
March	Opening of the Rebel Art Centre at 38 Great Ormond Street Lewis proposed that this centre should be an applied art workshops, an art school with himself as Professor of Painting, and a meeting place for social events, not unlike the Cabaret Theatre Club
27 March	Death of Spencer Gore
April	The Omega Workshops decorates the entrance hall and three other rooms on the first floor of 1 Hyde Park Gardens, the home of Lady Ian Hamilton. Bell designs a mosaic floor for the hall and a rug. Two stained-glass windows, the circular one designed by Fry, adorn the hall

8 May-20 June 1914	Twentieth Century Art exhibition, Whitechapel Art Gallery The Omega Workshops has a massive entry of 79 numbers, and the paintings of the Rebel Art Centre group – Nevinson, Helen Saunders, William Roberts, Wadsworth, Frederick Etchells and Lewis – are hung together
12 June-2 July	Seventh London Salon of the Allied Artists Association, Holland Park Hall. The Omega Workshops presents a lounge decorated with their products, and the Rebel Art Centre show a booth with their applied art work
20 June	*Blast No. 1* published
July	Rebel Art Centre closes David Bomberg's first one-man exhibition at the Chenil Gallery
4 August	War declared
August-September	Omega Workshops provide the decorations for the Cadena Cafe, 59 Westbourne Grove
October	An illustrated catalogue of The Omega Workshops published
20 November-December	Exhibition at 33 Fitzroy Square of Recent Work and New Designs Suitable for Christmas Presents

1915

5 March	Henri Doucet killed in action in France
April	Grant and Bell work together at Eleanor House, Mary Hutchinson's country house at West Wittering, Sussex and they begin to decorate the interior
5 June	Henri Gaudier-Brzeska killed in action in France
10 June	A double exhibition opens at the Omega Workshops – Woodcuts by Roald Kristian and Costumes by Vanessa Bell. Kristian, the husband of Nina Hamnett, is a new member of the Omega. Bell's costumes are part of a new dress-making venture at the Workshops mostly due to her initiative. Certain fabrics are hand painted with dyes then sent to Douglas Pepler in Hammersmith to be made 'fast'
10 June	The Vorticist Exhibition opens at the Doré Galleries. Members of the Vorticist Group include Frederick Etchells, Gaudier-Brzeska, Roberts, Wadsworth and Lewis. Grant is one of the invited artists, and Fry is also asked if he wishes to show, but he is absent in France working for the Quaker's War Victims Relief scheme
20 July	*Blast No. 2* published

Summer 1915	Lewis, with Helen Saunders, paints murals for a first floor room at the Restaurant de la Tour Eiffel, Percy Street First publication by Douglas Pepler of the Hampshire House Workshops *The Devil's Devices* with text by Pepler and wood-engravings by Eric Gill
November	Publication of the first Omega Workshops book – *Men of Europe,* with text by Pierre-Jean Jouve, and woodcuts by Kristian
November	Exhibition of Recent Paintings by Fry, Alpine Club Gallery. Fry shows three abstract paintings, and a selection of Omega rugs and pottery
December	Publication of second Omega Workshops book – *Simpson's Choice,* with text by Arthur Clutton-Brook, and woodcuts by Kristian

1916

January	St Dominic's Press founded at Ditchling
February	Exhibition of Paintings by Vanessa Bell at the Omega, her first one-man exhibition
March	Grant and Bell move out of London, to Wisset Lodge, Halesworth Suffolk, so that Grant can undertake agricultural work, a task forced upon him because of his stance as a conscientious objector. Since he can only paint on Sundays during this period, his output is severely curtailed
April-May	Omega artists – Fry, Hamnett, Kristian and Dolores Courtney, a new member – decorate two rooms with murals at 4 Berkeley Street, the London flat of Arthur Ruck. Marquetried furniture and a large circular rug complete the decorations
Summer	William Roberts joins the Royal Field Artillery. Of the Rebel Art Centre artists, Etchells does not fight on medical grounds, Wadsworth serves in the RVNR from 1914-17, Lewis is exempted on medical grounds for the early part of the war, and Hamilton serves as a special constable
October	Grant and Bell take up residence at Charleston farmhouse, Firle, Sussex
9 October- 20 November	Eleventh Arts and Crafts Exhibition, Royal Academy. The Omega Workshops is invited to contribute a small entry, and pottery and textiles are shown
November	Mixed Exhibition of Still Life Paintings at the Omega. Exhibitors include Fry, Bell, Grant, Kristian and Hamnett

1917

January	Vorticist Exhibition, Penguin Club, New York, organised by Ezra Pound and John Quinn. Exhibitors include Lewis, Etchells, Wadsworth and Roberts
March	Leonard and Virginia Woolf buy a hand printing press. *Two Stories* by Virginia and L. S. Woolf, with woodcuts by Carrington, issued in July as the first separate publication of The Hogarth Press
April	Article by Fry, 'The Artist as Decorator', published in *Colour* magazine, along with a sketch of an Omega Workshops interior
June	Grant and Bell continue their decorations of Mary Hutchinson's house at West Wittering
17 July–September	Fry's exhibition – The New Movement in Art – opens in Birmingham. Exhibitors include Bell, Gaudier-Brzeska, Courtney, Doucet, Frederick Etchells, Fry, Grant, Hamnett and Kristian. The exhibition, slightly reduced, is shown at the Mansard Gallery, Heal's, in October
Summer	Roberts made an Official War Artist
October	Publication of third Omega Workshops book – *Lucretius on Death,* with translation by Robert Trevelyan, and woodcuts by Fry
November	Exhibition of Flowerpieces by Fry, Carfax Gallery
6 November–December	Mixed exhibition of Recent Paintings at the Omega. Exhibitors include Fry and Grant
December	Lewis is made an Official War Artist to the Canadian Corps Headquarters

1918

May-June	Memorial Exhibition of the work of Gaudier-Brzeska, Leicester Gallery
August	The Contemporary Art Society organises an exhibition – Englische Moderne Malerei – which is shown at the Kunsthaus, Zurich. Exhibitors include Bell, Fry, Grant, Etchells and Lewis. In the catalogue preface, Fry's Omega Workshops group is described as consisting of Fry, Grant, Bell and Etchells
September	Grant and Bell execute mural decorations for Maynard Keynes's rooms at 46 Gordon Square
26 October–November	Exhibition of Modern Paintings and Drawings and Dresses by Mlle Gabrielle Söene and New Omega Pottery. Exhibitors include Bell, Fry, Grant, Hamnett and Edward Wolfe, the most recent recruit to the Omega

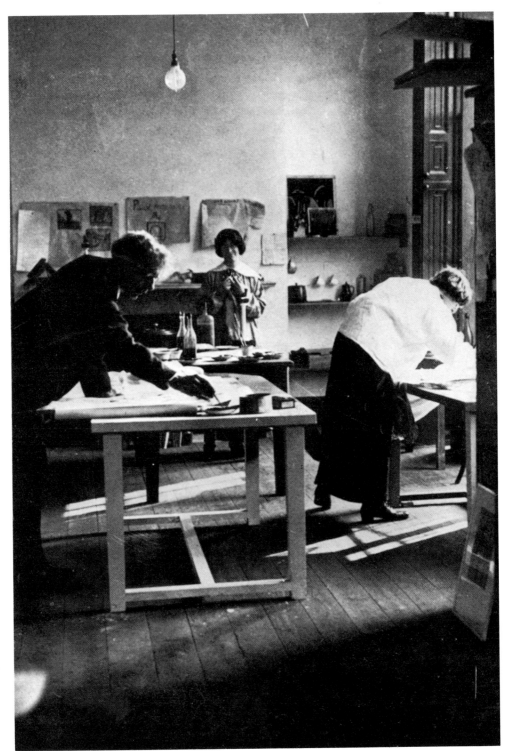

Roger Fry in the Omega Workshops

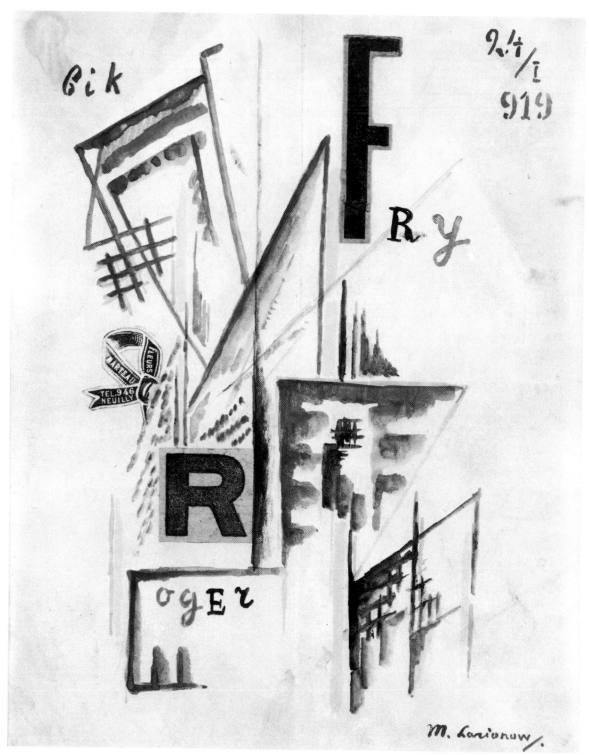

80 Mikhail Larionov *Homage to Roger Fry* 1919

December	Publication of fourth Omega Workshops book – *Original Woodcuts by Various Artists,* with work by Simon Bussy, Bell, Fry, Gertler, Grant, McKnight Kauffer, Kristian and Wolfe
Late 1918- early 1919	Grant and Bell execute decorations for Mary Hutchinson's London house at Hammersmith

1919

February	Exhibition of war paintings and drawings – Guns – by Wyndham Lewis, Goupil Gallery
21 February	Exhibition of sketches by Larionov, Drawings by Girls of Dudley High School and Recent Painted Furniture opens at the Omega
May	T. S. Eliot's *Poems* and Virginia Woolf's *Kew Gardens* (with woodcuts by Vanessa Bell) printed and published by Leonard and Virginia Woolf at the Hogarth Press
23 June- 9 July	Clearance Sale of Omega Workshops stock at 33 Fitzroy Square
Autumn	Roberts paints three mural panels for a room at the Restaurant de la Tour Eiffel, Percy Street

1920

Spring	Grant and Bell begin sketches for mural decorations for Maynard Keynes's rooms at Webb's Court, King's College, Cambridge. This scheme overlays Grant's earlier 1910-11 mural scheme
26 March- 24 April	Group X exhibition, Mansard Gallery, Heal's, organised by Lewis. Exhibitors include Etchells, Lewis, Hamilton, Roberts and Wadsworth
24 July	Omega Workshops Limited goes into voluntary liquidation

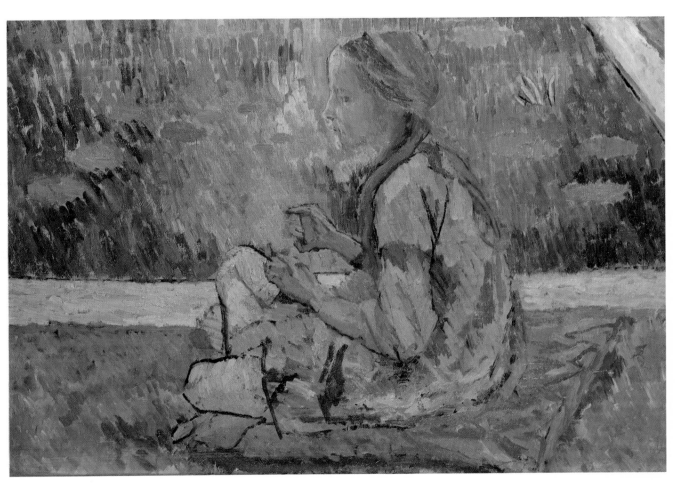

42 Duncan Grant *Pamela* 1911

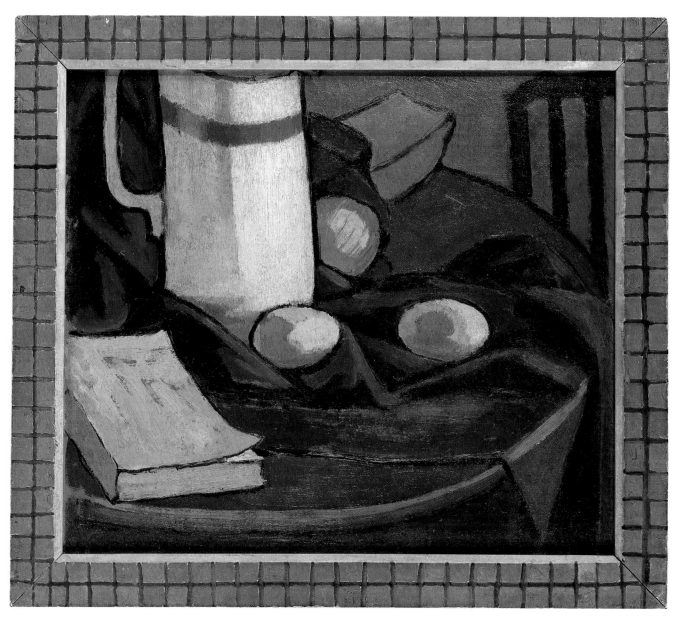

24 Roger Fry *Still Life: Jug and Eggs* 1911

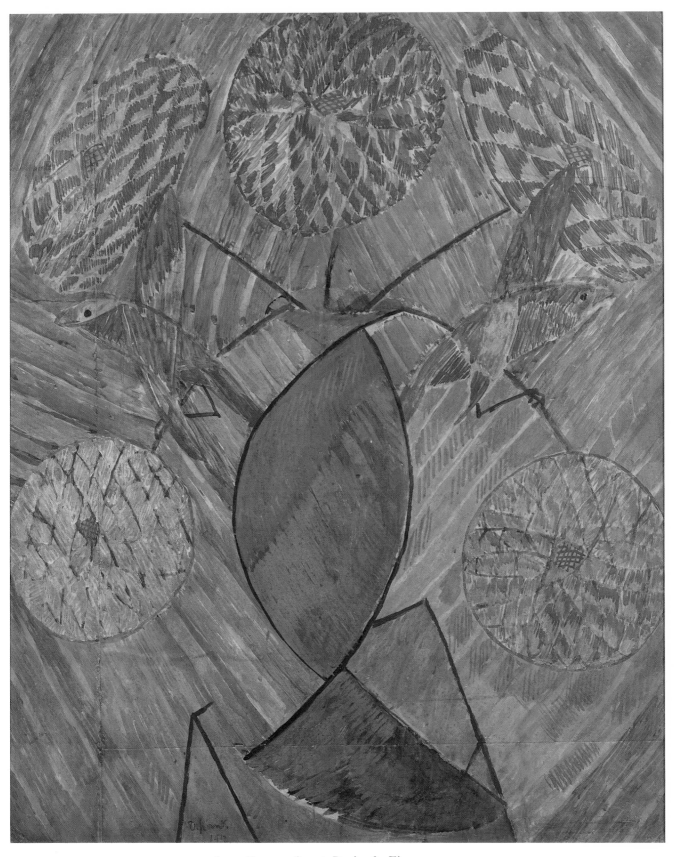

48 Duncan Grant *Design for Firescreen* 1912

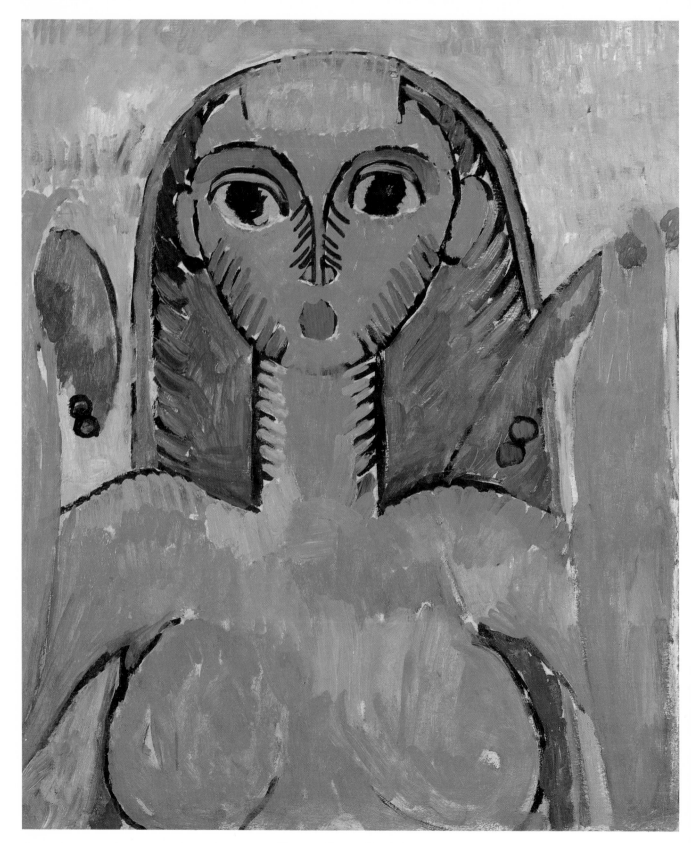

51 Duncan Grant *Head of Eve* 1913

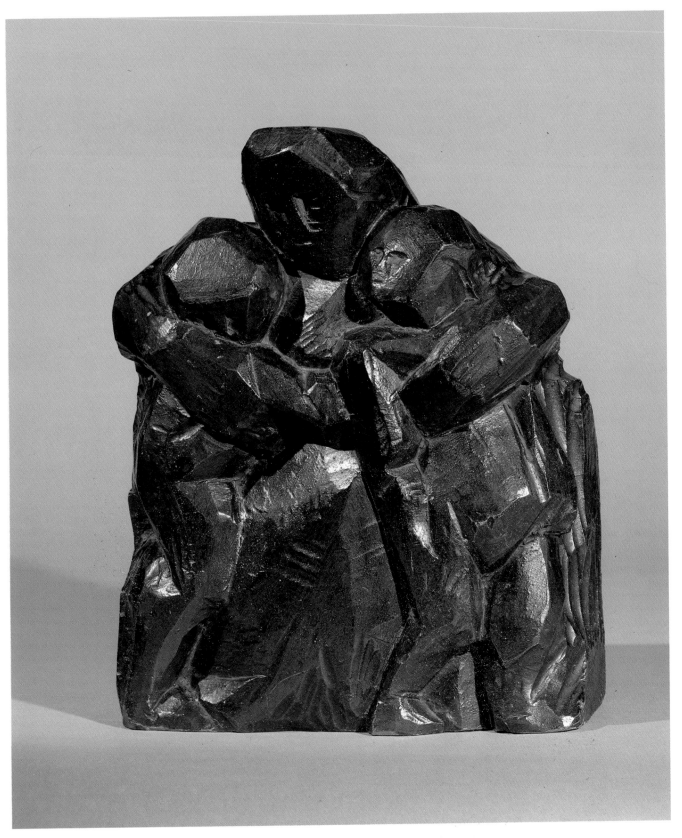

26 Roger Fry *Group: Mother and Children* 1913

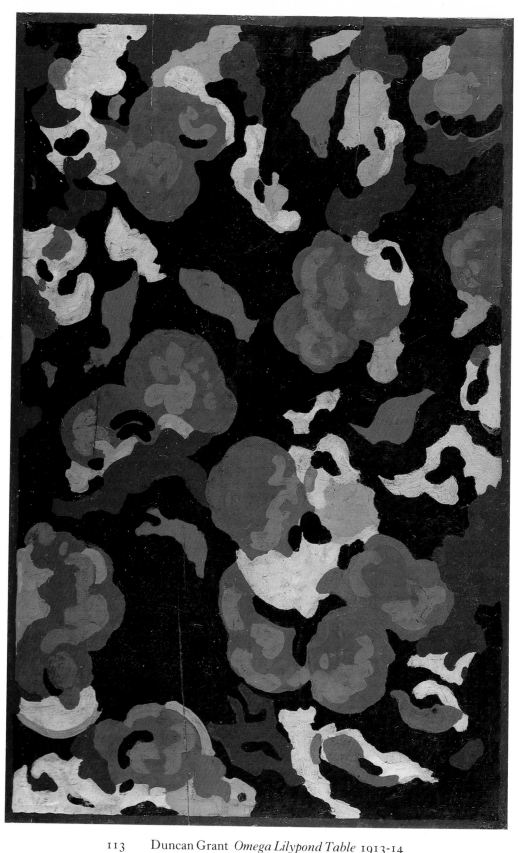

113 Duncan Grant *Omega Lilypond Table* 1913-14

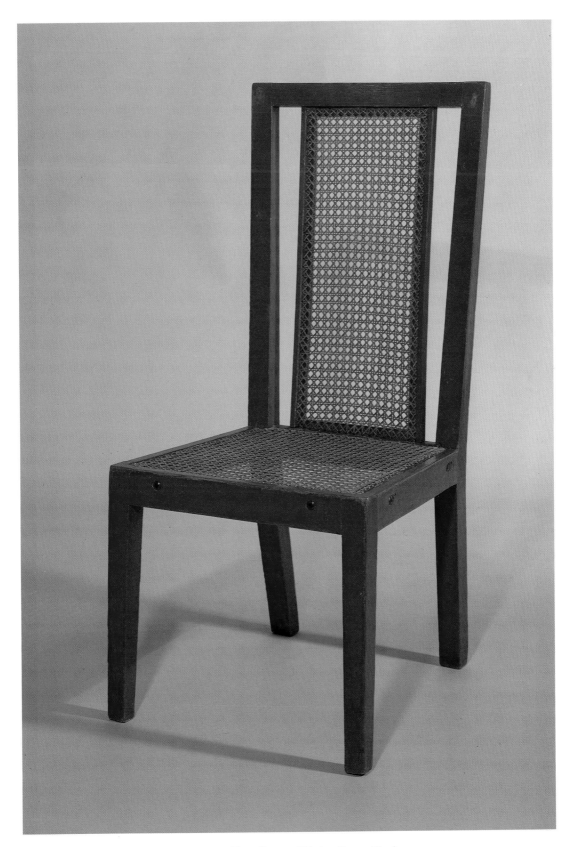

110 Roger Fry *Omega Dining Room Chair* 1913

53 Duncan Grant *Omega Design: Bathers* 1913-14
54 Duncan Grant *Omega Design: Abstract* 1913-14

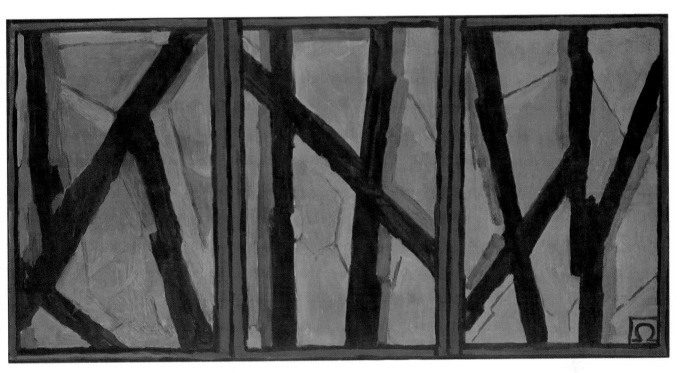

8 Vanessa Bell *Design for an Omega Rug* 1913-14

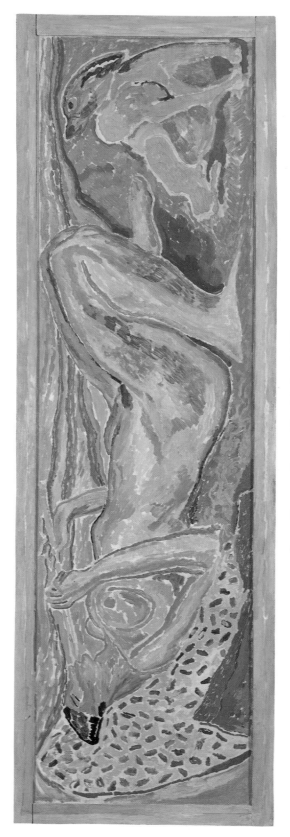

58 Duncan Grant *Blue Nude with Flute* 1914

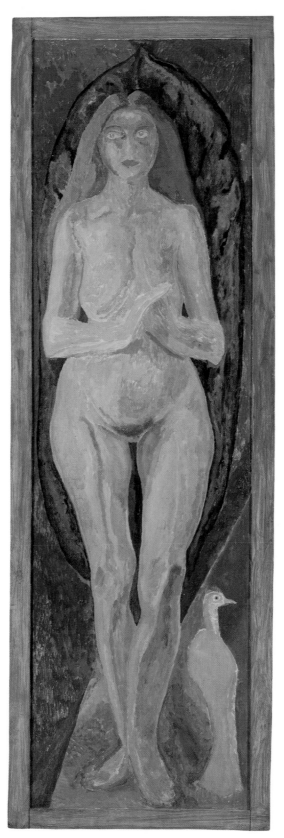

57 Duncan Grant *Standing Nude with Bird* 1914

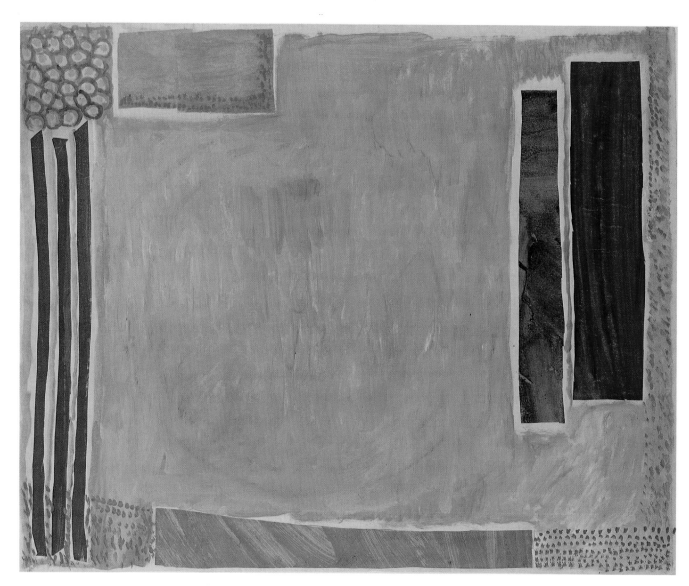

13 Vanessa Bell *Abstract Composition c.* 1914

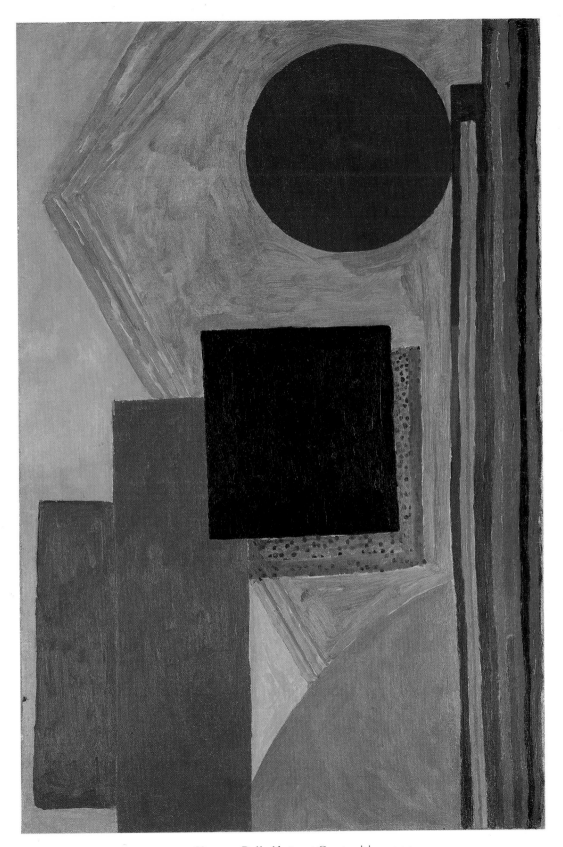

12 Vanessa Bell *Abstract Composition* 1914

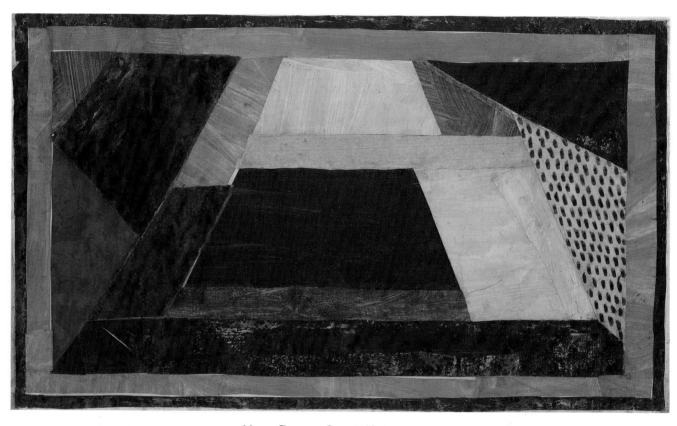

66 Duncan Grant *Abstract* 1915

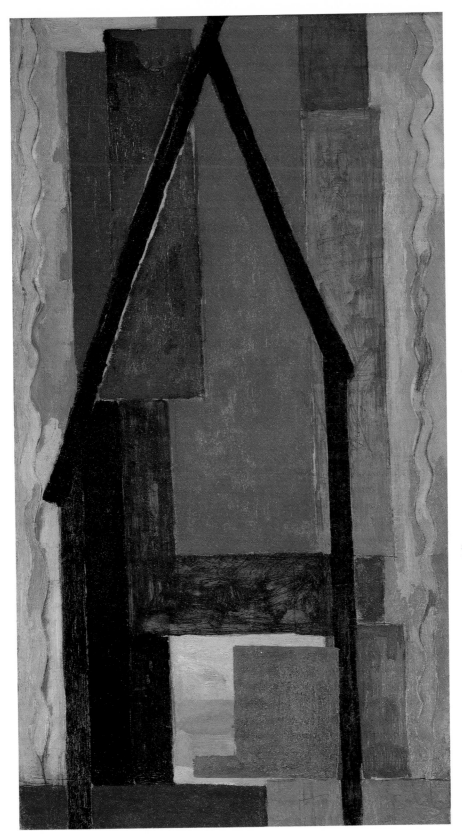

69 Duncan Grant *In Memoriam: Rupert Brooke* 1915

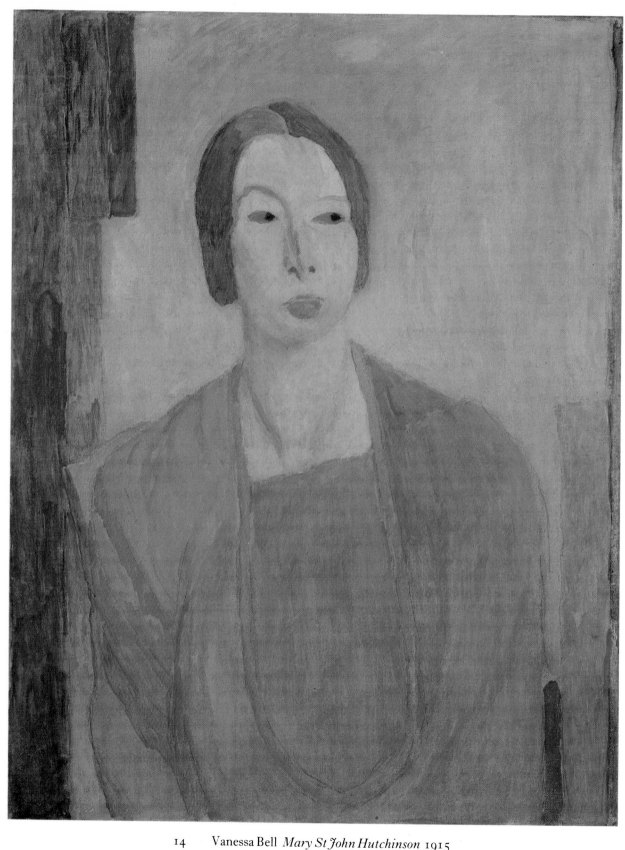

14 Vanessa Bell *Mary St John Hutchinson* 1915

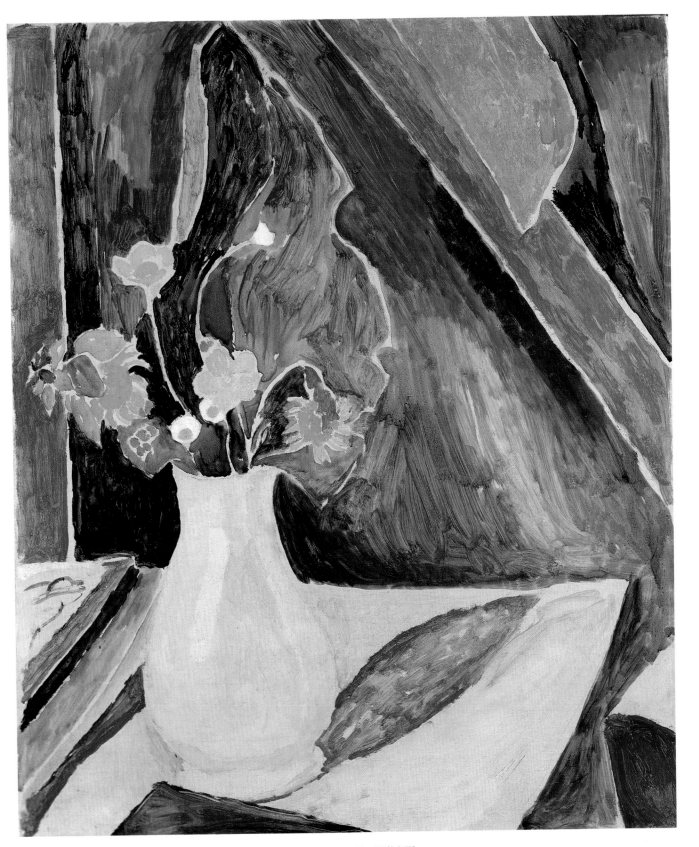

15 Vanessa Bell *Still Life: Wild Flowers c.* 1915

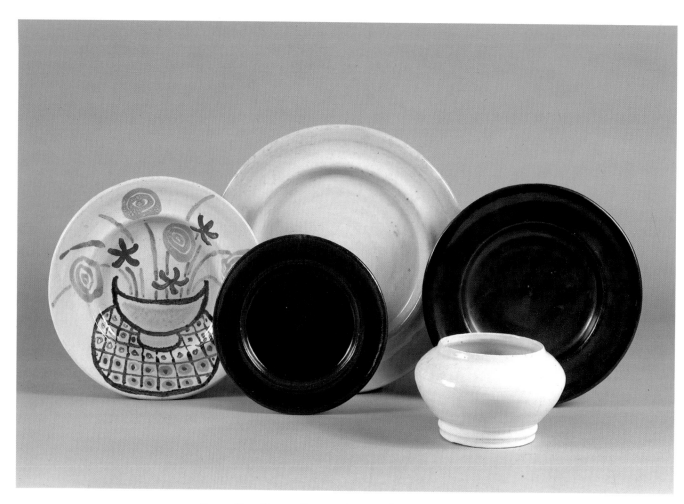

Roger Fry Omega Pottery (152, 148, 162b, 150a, 139)

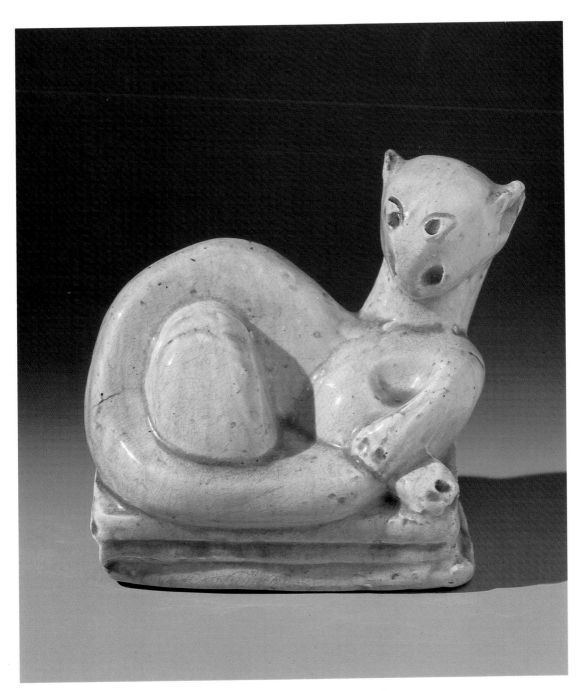

146 Henri Gaudier-Brzeska *Omega Cat* 1914

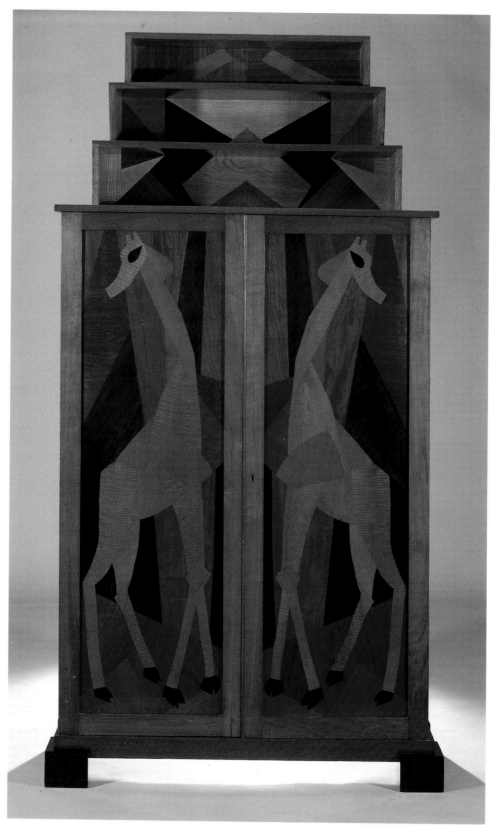

116 Roger Fry *Omega Giraffe Cupboard* 1915-16

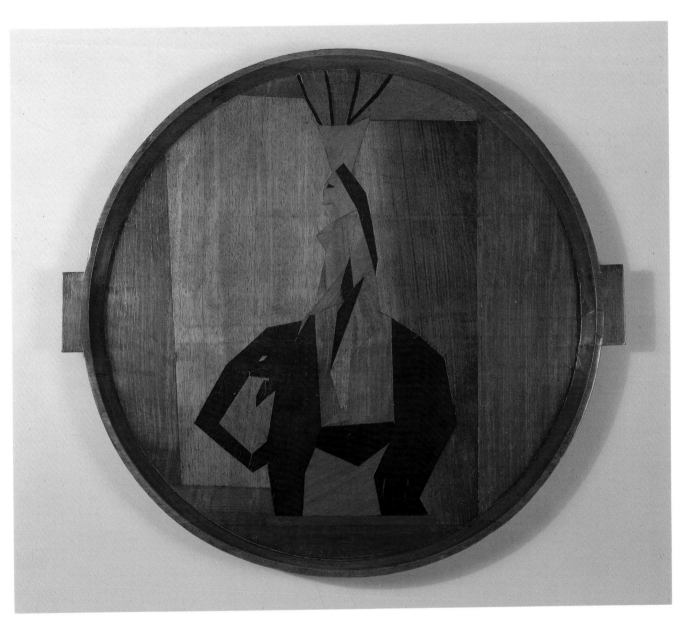

129 Duncan Grant *Omega Elephant Tray* 1914

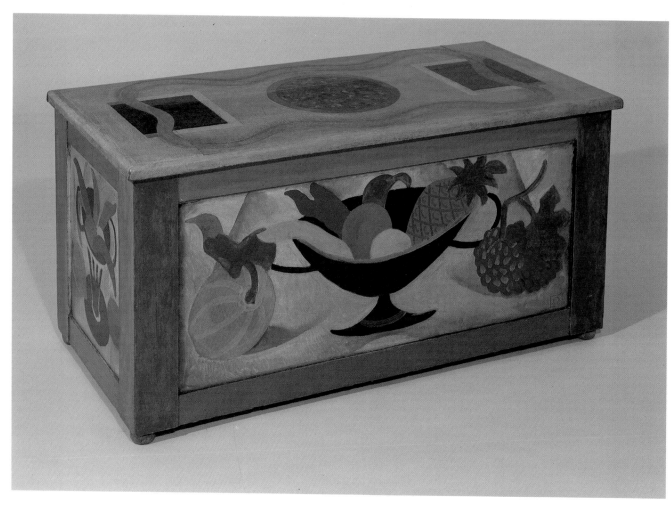

119 Roger Fry *Omega Toy Chest* 1916-17

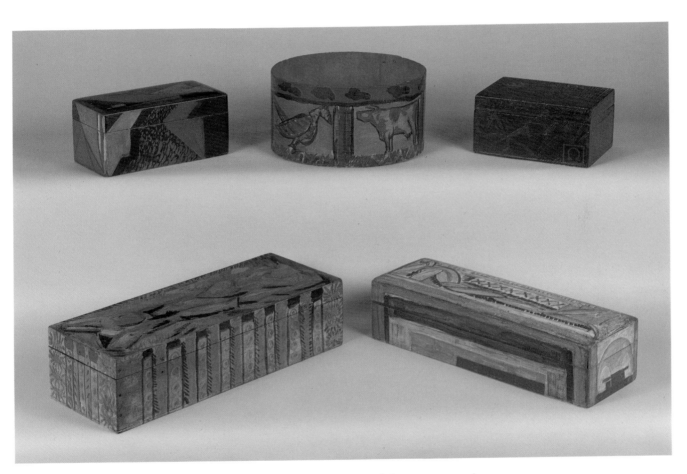

Omega Boxes (*top* 125, 123, 126 *bottom* 122, 124)

60 Duncan Grant *On the Mantelpiece: Omega Paper Flowers* 1914-15

VANESSA BELL (1879-1961)

1 **Design for a Screen: Figures by a Lake** 1911-12
Gouache on board
9¾ x 17¼ in
Provenance: The Artist's Family

This may be the *Design for a Screen* (no 11) shown by Vanessa Bell in the Friday Club exhibition held at the Alpine Club Gallery from 10th to 24th February 1912. The same title appears again in Fry's exhibition of English artists at the Galerie Barbazanges, Paris in May 1912 (no 5). The scene depicted, that of a lake set amidst tall pine trees and bare heath-like ground, is not unlike the hinterland of Studland Beach, a favourite holiday place for the Bell family at this time. Vanessa Bell spent the whole of September 1911 at Studland, painting much of the time. Nude bathing was usual at Studland, so the subject-matter is not drawn from the imagination, but from life. To be designing the decoration for a three-fold screen in the winter of 1911 shows that Vanessa Bell was not dependent on the founding of the Omega Workshops for the motivation to paint domestic furniture. When she painted a four-fold screen in the winter of 1913 for the Omega Workshops, she used the same subject-matter (*Bathers in a Landscape,* Victoria & Albert Museum).

2 **Roger Fry** 1912
Oil on panel
11½ x 9¼ in
Provenance: The Fry Family
Exhibited: Alpine Club Gallery *Friday Club Exhibition* 1912 no 12 as 'Portrait Sketch'; Galerie Barbazanges, Paris *Exposition de Quelques Independants Anglais* 1912 no 3; Mappin Art Gallery, Sheffield *Vanessa Bell* Centenary Exhibition 1979 no 10
Literature: Denys Sutton *Letters of Roger Fry* 1972, I, fig 55

This important portrait was painted when both Roger Fry and Vanessa Bell spent a short holiday at Niton on the Isle of Wight between 12th and 19th January 1912. In the autumn of 1911 Grant had adopted a pseudo-pointilliste technique, a method of utilising large dabs of unmixed paint, which Vanessa Bell christened his 'leopard manner'; both she and Fry tried it while they were at Niton. Vanessa Bell wrote of this portrait to Clive Bell: 'I did a sketch of Roger yesterday in Duncan's leopard manner with odd results but very like . . .' (16 January 1912).

3 **Henri Doucet** 1912
Oil on panel
16½ x 13⅝ in

Provenance: The Artist's Family

Exhibited: Miller's, Lewes *The Omega Workshops* 1946 no 21; Arts Council *Vanessa Bell* Memorial Exhibition 1964 no 16; Fine Art Society, London *Bloomsbury Portraits* 1976 no 5; Davis & Long, New York *Vanessa Bell, A Retrospective Exhibition* 1980 no 10 (reproduced); Royal Museum, Canterbury *Vanessa Bell, Paintings 1910-1920* 1983 no 15

Literature: Richard Shone *Bloomsbury Portraits* 1976 (pl 43; see also pl 119)

The French painter Henri Doucet (1883-1915) met Roger Fry in Paris in 1911 through their mutual friend Charles Vildrac, and came to England in the summer of that year to visit Fry. In August 1912 he stayed with Vanessa Bell and Duncan Grant at Asheham, Virginia Woolf's country house, while she was abroad on her honeymoon. It was most probably on this visit that Grant painted Doucet at the same time as Bell painted the present picture, and Bell also painted *The Studio: Duncan Grant and Henri Doucet Painting at Asheham* (4). Doucet was in London in July 1913 for the opening of the Omega Workshops – Winifred Gill remembered that he painted the walls of one of the showrooms with a pattern of leaves, using a homemade template.

4 **The Studio: Duncan Grant and Henri Doucet Painting at Asheham** 1912
Oil on board
23 x 18¼ in

Provenance: The Artist's Family

Exhibited: Clifton Arts Club, Bristol 1913 no 8 as 'The Studio'; Adams Gallery, London *Vanessa Bell* 1961 no 4; Arts Council *Vanessa Bell* Memorial Exhibition 1964 no 17; Royal West of England Academy, Bristol *Paintings by Duncan Grant and Vanessa Bell* 1966 no 66; Clare College, Cambridge *Modern British Paintings from Local Collections* 1970; Anthony d'Offay *Vanessa Bell, Paintings and Drawings* 1973 no 8 (reproduced); Fine Art Society, Edinburgh *Duncan Grant and Bloomsbury* 1975 no 31; Fine Art Society, London *Bloomsbury Portraits* 1976 no 7; Davis & Long, New York *Vanessa Bell, A Retrospective Exhibition* 1980 no 11 (reproduced); The Royal Museum, Canterbury *Vanessa Bell, Paintings 1910-1920* 1983 no 16 (reproduced)

Literature: Quentin Bell *Bloomsbury* 1974 (reproduced in colour on cover and in black and white between pp 48-49); Richard Shone *Bloomsbury Portraits* 1976 pp 75-77

5 **Design for Fireplace Mural** *c*.1912
Oil on paper
30 x 22 in
Provenance: The Artist's Family
Exhibited: Folio Fine Art, London *Vanessa Bell, Drawings and Designs*
 1967 no 5; Davis & Long, New York *Vanessa Bell, A Retrospective*
 Exhibition 1980 no 17
Literature: Judith Collins *The Omega Workshops* 1984 (pl 3)

A sketch for a proposed mural decoration above a fireplace. Vanessa Bell
was unable to participate in Fry's Borough Polytechnic mural scheme in
the summer of 1911 because of illness, but in the spring of 1912 she was
included in the Mill Street Group, formed by Fry to provide mural
decorations for the Middlesex Hospital, as the Bloomsbury entry in a
Mural Decorations Competition announced in *The Times* of 5th February
1912, 'to promote the practice of mural painting in schools, churches,
hospitals, and other public institutions, more especially by young
artists . . .'.
 The subject is two naked females in conversation; in style and content
the design is a counterpart to her painting *Street Corner Conversation* of
early 1913.

6 **Design for the Omega Fabric,** *Maud* 1913
Gouache
18 ⅞ x 26 ⅞ in
Provenance: The Artist's Family
Exhibited: Arts Council *Vorticism and its Allies* 1974 no 123
 (reproduced); Davis & Long, New York *Vanessa Bell, A Retrospective*
 Exhibition 1980 no 19
Literature: Richard Cork *Vorticism and Abstract Art in the First Machine*
 Age 1976, I, (reproduced in colour p 89)

Fry encouraged Bell and Grant to design patterns for the Omega series of
linens in the spring of 1913, so that they could be produced in time for the
proposed opening date of 8th July 1913. Of the six printed linens (see no
130) *Maud* and *White* are definitely attributable to Bell. When *Maud* was
printed, the pattern was available in four different versions, in all of which
the background was white. This design, like *Design for the Omega Fabric,*
Mechtilde (Victoria & Albert Museum), was probably also intended for a
rug. The background is given a solid colour and the design is drawn on
graph paper, ready for the craftsman to translate into a handknotted rug.

7 **Design for an Omega Fabric** 1913
Pencil and watercolour
20¾ x 15¾ in
Provenance: The Artist's Family
Exhibited: Arts Council *Vorticism and its Allies* 1974 no 122

This design was not in fact printed, for the probable reason that by the winter of 1913-14, with the Omega capital exhausted, Fry was unwilling to extend the range of printed fabrics.

8 **Design for an Omega Rug** 1913-14
Oil on paper
12 x 23¾ in
Inscribed with Omega symbol and stamped under mount with Omega
 Workshops Imprint
Provenance: The Artist's Family
Exhibited: Arts Council *Vorticism and its Allies* 1974 no 121; Davis &
 Long, New York *Vanessa Bell, A Retrospective Exhibition* 1980 no 20
Literature: Quentin Bell *Bloomsbury* 1974 (rug reproduced between pp
 48-49); Richard Shone *Bloomsbury Portraits* 1976 p 117 pl 70 (see also
 pl 71); Isabelle Anscombe *Omega and After* 1981 (rug reproduced pl
 13); Judith Collins *The Omega Workshops* 1984 (rug reproduced pl 40)

This rug design dates from approximately the same time as the screen *Bathers in a Landscape* (Victoria & Albert Museum). The subject matter of the screen was inspired by a camping holiday Vanessa Bell spent with Fry, Grant, and others, in August 1913, and its composition relies upon the juxtaposition of tent poles and the taut lines of tent canvas with the sweeping curves of the surrounding foliage. The rug design takes the composition of the screen a step further; it retains the lines of tent poles and canvas, but rejects the curves of the foliage.
 In March 1914 Sir Ian and Lady Hamilton commissioned the Omega Workshops to decorate several rooms in their house at 1 Hyde Park Gardens, and at least four versions of this rug were used in the entrance hall. Further examples were prominently displayed in the Omega section of the Allied Artists' Salon at Holland Park Hall from June to July 1914. The rug was praised by Henri Gaudier-Brzeska in his review of the Allied Artists' Salon in *The Egoist* (15th June 1914).

9 **Girl by a Tent** 1913
Oil on board
20¾ x 14⅝ in
Provenance: The Artist's Family
Literature: Judith Collins *The Omega Workshops* 1984 (pl 31)

Painted during a camping holiday at Brandon, near Thetford, Norfolk, in August 1913, this work shows one of the Olivier sisters. It relates to Vanessa Bell's *Summer Camp* 1913 and her Omega screen *Bathers in a Landscape* (Victoria & Albert Museum).

10 **Design for Omega Bed-end: Adam and Eve** 1913
Pencil, gouache and oil on paper
9¾ x 26¼ in
Provenance: The Artist's Family
Exhibited: Folio Fine Art *Vanessa Bell, Drawings and Designs* 1967 no 2;
 Anthony d'Offay *Vanessa Bell, Paintings and Drawings* 1973 no 10;
 National Book League *The Bloomsbury Group* 1976 no 88; Davis &
 Long, New York *Vanessa Bell, A Retrospective Exhibition* 1980 no 18
Literature: Quentin Bell *Bloomsbury* 1974 (reproduced between pp 48-
 9); Frances Spalding *Vanessa Bell* 1983 (reproduced between pp 208-9)

In the summer of 1913 Duncan Grant had painted a pair of curtains to hang between the two showrooms at the Omega Workshops with a scene of Adam and Eve in Paradise (see p 14). In the autumn and winter of that year he painted a *Head of Eve* (51) and a large canvas *Adam and Eve*. This part of the Genesis story would have been much in Vanessa Bell's thoughts at the time.

11 **Design for Omega Bed-head: Woman Reading** 1913
Pencil, gouache and oil on paper
9¾ x 25½ in
Private Collection
Exhibited: Folio Fine Art *Vanessa Bell, Drawings and Designs* 1967 no 1

Reclining figures, usually nude, were popular as the basis for Omega bed-head designs. This work may relate to an idea Vanessa Bell once described in a letter, of designing a bed-head in the mood of Frederick Leighton's *Flaming June*.

12 **Abstract Composition** 1914

Oil on canvas

36½ x 24½ in

Provenance: The Artist's Family

Literature: Judith Collins *The Omega Workshops* 1984 (reproduced in colour pl I)

Vanessa Bell's and Duncan Grant's non-figurative paintings were certainly contemporary with the abstraction of their applied designs for the Omega Workshops. Temperamentally Vanessa Bell was more inclined to paint non-referential abstraction as in her *Abstract c.* 1914 (Tate Gallery) to which this work is closely related, though this is larger in scale and more adventurous in composition. Several abstract works by the two painters were either destroyed or painted over. Their abstract phase, *c.* 1913-16, though never pursued exclusively, appears increasingly substantial.

13 **Abstract Composition** *c.* 1914

Oil, gouache and *papier collé* on paper

19¼ x 24⅛ in

Provenance: The Artist's Family

Exhibited: Anthony d'Offay *British Paintings, Drawings and Sculpture 1890-1975* 1975 no 3; Mappin Art Gallery, Sheffield *Vanessa Bell Centenary Exhibition* 1979 no 16; Davis & Long, New York *Vanessa Bell, A Retrospective Exhibition* 1980 no 22 (reproduced); Royal Museum, Canterbury *Vanessa Bell, Paintings 1910-1920* 1983 no 24

Literature: Richard Shone *Bloomsbury Portraits* 1976 pl 91; Richard Shone 'Vanessa Bell' *The Burlington Magazine* October 1979 p 673 (reproduced); Frances Spalding *Vanessa Bell* 1983 (reproduced in colour pl 4); Judith Collins *The Omega Workshops* 1984 (pl 75)

Vanessa Bell learnt to employ *papier collé* while designing at the Omega Workshops, and her largest and most magnificent cut paper work was the *Ideal Nursery* unveiled at 33 Fitzroy Square in December 1913. It was there that she designed *papier collé* murals and a ceiling on the theme of animals in a landscape setting. Such an environment would not be matched until Matisse executed his late works in *papier collé* forty years later.

14 **Mary St John Hutchinson** 1915
Oil on canvas
31 x 23¾ in
Provenance: The Fry Family
Exhibited: The Omega Workshops *Paintings by Vanessa Bell* 1916;
 Mansard Gallery, Heal's *The New Movement in Art* 1917 no 5;
 Beaverbrook Art Gallery, Fredericton, Canada *Bloomsbury Painters
 and Their Circle* 1976 no 10; Mappin Art Gallery, Sheffield *Vanessa
 Bell,* Centenary Exhibition 1979 no 21; The Royal Museum,
 Canterbury *Vanessa Bell, Paintings 1910-1920* 1983 no 31
Literature: W. R. Sickert in 'A Monthly Chronicle' *The Burlington
 Magazine* 1916; Tate Gallery *Biennial Report 1972-74* 1975 pp 85-86;
 Richard Shone *Bloomsbury Portraits* 1976 p 173 pl 107; Frances
 Spalding *Vanessa Bell* 1983 (reproduced between pp. 208-209)

The sitter is Mary Hutchinson (*née* Barnes), second cousin of Lytton
Strachey and Duncan Grant, who in 1910 married St John Hutchinson.
She was a hostess, writer and patron of the Omega Workshops. Another
very similar version of this painting is in the Tate Gallery. Both were
painted at 46 Gordon Square in February 1915. Duncan Grant painted
Mary Hutchinson on the same occasion. (63).

15 **Still Life: Wild Flowers** *c.* 1915
Oil on canvas
30¼ x 25 in
Provenance: Duncan Grant
Exhibited: Miller's Lewes *An Exhibition of English and French Paintings*
 1943 no 23; Adams Gallery *Paintings by Vanessa Bell* 1961 no 7; Arts
 Council *Vanessa Bell* Memorial Exhibition 1964 no 31 (reproduced
 pl 3); Royal West of England Academy, Bristol *Paintings by Duncan
 Grant and Vanessa Bell* 1966 no 109; Davis & Long, New York *Vanessa
 Bell, A Retrospective Exhibition* 1980 no 16

Although given the date 1913 in previous exhibitions, this important
painting may well have been executed in early summer 1915 at Eleanor,
West Wittering, or at the Grange, Bosham.

16 **David Garnett** 1915
Gouache and oil on board
30 x 20½ in
Provenance: The Artist's Family
Exhibited: Anthony d'Offay *Vanessa Bell, Paintings and Drawings* 1973
 no 15; Fine Art Society, Edinburgh *Duncan Grant and Bloomsbury*
 1975 no 36; Fine Art Society, London *Bloomsbury Portaits* 1976 no 19;
 Mappin Art Gallery, Sheffield, *Vanessa Bell*, Centenary Exhibition
 1979 no 17; Royal Museum, Canterbury *Vanessa Bell, Paintings 1910-*
 1920 1983 no 34
Literature: Quentin Bell *Bloomsbury* 1974 (reproduced between pp 48-
 49); Richard Shone *Bloomsbury Portraits* 1976 p 140 (pl 97); Frances
 Spalding *Vanessa Bell* 1983 p 141

Painted in April or May 1915 at West Wittering, near Chichester, when
Eleanor, a house rented by St John and Mary Hutchinson had been lent
for several weeks to Vanessa Bell and Duncan Grant. The writer David
Garnett (1892-1981) posed on many occasions for Grant and on this
occasion for the two artists together, probably in Professor Tonks' studio-
boathouse on the Chichester estuary, a short walk from Eleanor. Grant's
painting, in a private collection, shows a more erotic presence than
Vanessa Bell's more boyish interpretation. It is the only male nude portrait
in her work.

17 **Duncan Grant Painting** 1915
Oil on canvas
20 x 16 in
Provenance: The Artist's Family
Exhibited: Morris Gallery, Toronto *Artists of the Bloomsbury Group* 1977
 no 1 (reproduced); Davis & Long, New York *Vanessa Bell, A*
 Retrospective Exhibition 1980 no 30 (reproduced); Royal Museum,
 Canterbury *Vanessa Bell, Paintings 1910-1920* 1983 no 30
Literature: Germaine Greer *The Obstacle Race* 1979 (reproduced in
 colour pl 26)

Probably painted at Eleanor, West Wittering or The Grange, Bosham,
Sussex in the summer of 1915.

18 **Tea in the Nursery** *c.*1915
Pencil, oil and gouache on paper
15½ x 27½ in
Provenance: The Artist's Family
Exhibited: Davis & Long, New York *Vanessa Bell, A Retrospective Exhibition* 1980 no 30; Royal Museum, Canterbury *Vanessa Bell, Paintings 1910-1920* 1983 no 29

Probably related to a decorative project for the Omega Workshops. *Tea in the Nursery* is a subject Vanessa Bell had treated previously. It bears strong connections with Grant's large painting *The Kitchen c.*1914 (Tate Gallery) in its combination of the fantastic and the domestic.

19 **Design for Omega Bed-end: Vase of Flowers** 1917
Oil and gouache on paper
15 x 37 in
Provenance: The Artist's Family

The plain vertical surfaces of a bed-head and bed-end invited decorative treatment. Roger Fry painted a bed for Mme Lalla Vandervelde, Duncan Grant one for Vanessa Bell ('Morpheus' bed, The Charleston Trust) and Vanessa Bell one for Mary Hutchinson and another for Barbara Bagenal. A custom emerged at the Omega Workshops of painting a reclining female nude for the bed-head, and a bowl of fruit or a vase of flowers for the bed-end. The large, bending flowers of this work relate to the bedroom door decorations by Vanessa Bell of 1918 at Charleston and were a feature of many Omega designs – the back of Grant's Omega signboard for example (see also nos 10, 11 and 20).

20 **Pineapple and Candlesticks** *c.* 1916
Oil on canvas
8¾ x 17¼ in
Provenance: The Artist's Family
Exhibited: The Fine Art Society, Edinburgh *Duncan Grant and Bloomsbury* 1975 no 35

An inventory by Vanessa Bell of paintings at Charleston lists '17 x 9 in Study for decor. (bed)' and it is likely this is *Pineapple and Candlesticks*. It is a variant on the usual Omega decoration for a bed-end, since the bowl of fruit is flanked by candlesticks.

21 **Tea Things** 1917 and 1919
Oil on panel
14¾ x 37 in
Signed and dated
Provenance: Clive Bell
Exhibited: Mansard Gallery, Heal's, *The New Movement in Art* 1917 no
 11; A.I.A. Gallery *Fitzroy Street Retrospective 1910-1920* 1955 no 22;
 Arts Council *Vanessa Bell* Memorial Exhibition 1964 no 38; Davis &
 Long, New York *Vanessa Bell, A Retrospective Exhibition* 1980 no 34;
 Royal Museum, Canterbury *Vanessa Bell, Paintings 1910-1920* 1983 no
 37

Although in size and format this work bears a strong relationship to the
Omega bed-heads decorated by Vanessa Bell, she regarded this as a
painting and sent it to exhibitions. It was shown in Fry's *The New
Movement in Art* exhibition in Birmingham and London in July and
October 1917 respectively (no 11, price £10). In 1919 she reworked the
painting. When Picasso and Derain were shown around 46 Gordon
Square by Duncan Grant he told Vanessa Bell that it was the picture they
liked most in the house.

See also nos 78, 128, 130, 132, 133, 136, 152.

FREDERICK ETCHELLS (1886-1973)

22 **Figure: Running Man** 1914-15
Watercolour and pencil
11½ x 8⅞ in
Signed
Private Collection

Etchells' period of association with the Omega lasted from January to
October 1913 but only a handful of objects can be attributed to him from
this time. He designed a rug, which accompanied one by Grant, for the
Omega sitting room at the Ideal Home Exhibition, and Fry must have
thought highly of it since he chose it to illustrate the category of 'Carpets'
with a black and white photograph in the Omega Workshops descriptive
illustrated catalogue 1914 (p 11). Three rug designs by Etchells survive,
which use the same triangular and square confrontation. Grant recalled
that his painting *The Mantelpiece* (Tate Gallery) contains the portrayal of
a painted Omega box by Etchells, on the theme of a swimmer. *Figure:
Running Man* shows the development of Etchells' style after he had left
the Omega, but still owes a large debt to the experimentation practised
there.

See also nos 25, 47.

ROGER FRY (1866-1934)

23 **E. M. Forster** 1911
Oil on canvas
28½ x 23¼ in
Painted frame by the artist
Provenance: E. M. Forster; Evart Barger
Exhibited: Alpine Club Gallery *Paintings and Drawings by Roger Fry*
 1912 no 2; Arts Council *Vision and Design* 1966 no 10; Courtauld
 Institute Galleries *Portraits by Roger Fry* 1976 no 6; (pl 3)
Literature: Quentin Bell *Bloomsbury* 1974 (reproduced between pp 48-
 9); P N Furbank *E M Forster, A Life,* I, 1977 pp 205-7 (reproduced in
 colour on dust jacket); Frances Spalding *Roger Fry, Art and Life* 1980
 (pl 51)

In January 1912 Fry had a one-man exhibition of 52 works at the Alpine
Club Gallery, Mill Street, in which this portrait of Forster, who sat for
Fry in December 1911, was titled 'A Novelist'. Forster reported on the
painting to a friend: 'Roger Fry is painting me. It is too like me at present,
but he is confident he will be able to alter that. Post-Impressionism is at
present confined to my lower lip which is reduced thus . . . and to my chin
on which soup has apparently dribbled. For the rest you have a bright,
healthy young man, without one hand it is true, and very queer legs,
perhaps the result of an aeroplane accident, as he seems to have fallen from
an immense height on to a sofa.'

 The strong, rather hard-edged form of the novelist is offset by the
various patterns of the cushions around him on the armchair, and this
interesting opposition gives us a clue to Fry's aesthetic outlook at the
beginning of 1912. It was still over a year before he was to set up the
Omega Workshops, but he was already interested in materials and
patterns. Indeed, finding the brown plush of the settees in the Alpine
Club Gallery too unsympathetic, he covered them with a fabric of red and
white squares. He also had special frames made for a few of his canvases,
about two inches wide, and these too he painted, usually with a chequer-
board pattern.

24 **Still Life: Jug and Eggs** 1911
Oil on board
12 x 14 in
Signed and dated
Painted frame by the artist
Provenance: The Artist

Literature: Quentin Bell & Stephen Chaplin 'The Ideal Home Rumpus' *Apollo* October 1964 pp 284-291 (reproduced); Richard Cork *Vorticism and Abstract Art in the First Machine Age* 1976 (reproduced p 90); Judith Collins *The Omega Workshops* 1984 (reproduced in colour)

Fry probably showed this painting in his one-man exhibition at the Alpine Club Gallery in January 1912. Like other pictures in the show it has a chequerboard frame. Fry however kept the painting for his own collection and later that year sent it to the 1912 Venice Biennale, from which it still bears the label. *Still Life: Jugs and Eggs* formed the inspiration for *Amenophis* (130a), an Omega linen produced in France and available in July 1913 when the Omega Workshops opened. A similar painting (without the yellow book) exists, painted at the same time by Vanessa Bell.

25 **Three Designs for the Omega Fabric,** *Mechtilde* 1913
Pencil and watercolour
a) 6 x 8 in
b) 8 x 4¼ in
c) 8 x 4⅛ in

Preliminary designs for *Mechtilde*, (130d). Etchells has long been credited as the originator of *Mechtilde*, but since notes in Fry's hand appear on these designs, it seems likely that they are his.

26 **Group: Mother and Children** 1913
Painted wood
11¼ x 9⅛ x 3⅞ in
Provenance: Wolf Posner; The Fry Family
Exhibited: Alpine Club Gallery *Second Grafton Group Exhibition* 1914; Whitechapel Art Gallery *British Sculpture in the Twentieth Century* 1981 no 42

Roger Fry's only known carving. The design is based on a photograph of Vanessa Bell kneeling and embracing her two sons Julian and Quentin, then aged five and three respectively. Both Fry and Grant used the sculpture as the basis for Christmas card designs drawn for the Omega in

December 1913. Vanessa Bell's role for Fry and Grant in 1913 was described by her sister as 'a mixture of Goddess and peasant, treading the clouds with her feet and with her hands shelling peas . . .'. The carving was shown on the mantelpiece of the Omega sitting room at the Ideal Home Exhibition in October 1913 and is illustrated in the Omega Workshops catalogue of 1914 (p 6).

27 **South Downs** 1914
Oil on panel
17¾ x 24 in
Signed and dated
Exhibited: Alpine Club Gallery *Second Grafton Group Exhibition* 1914;
 Whitechapel Art Gallery *Twentieth Century Art*, 1914
Literature: Frances Spalding *Roger Fry, Art and Life* 1980 p 170 (pl 60)

The First Grafton Group exhibition in 1913 included paintings, sculpture and some painted furniture by the future Omega colleagues Grant, Bell, Fry, Lewis and Etchells as well as by invited artists such as Spencer Gore, Max Weber and Kandinsky. The second show, following the defection of Lewis and Etchells to the Rebel Art Centre, was supplemented by the work of several French artists including Doucet, Lhôte, Friesz and Marchand and two artists associated with the Omega, William Roberts and Gaudier-Brzeska. Grant showed *Adam and Eve* and *The Ass*, and Fry showed several landscapes including *South Downs,* probably begun in the autumn of 1913 when he stayed with the Bells at Asheham House.

28 **Design for Omega Giraffe Cupboard** 1915
Pencil, chalk, gouache and *papier collé* on tracing paper
14¼ x 8½ in
Victoria & Albert Museum
Literature: Isabelle Anscombe *Omega and After* 1981 (pl 17); Judith
 Collins *The Omega Workshops* 1984 (pl 66)

Fry began to use *papier collé* during 1914. Like Grant and Bell, he was encouraged to use it by the working methods of the Omega: the simplest way to indicate the various pieces of wood when designing a work to be translated into marquetry was to use coloured pieces of paper cut into shape, imitating the marquetry process. Fry has done exactly this – cutting out pieces of grey, brown and black paper as a design for the craftsman, no doubt John Joseph Kallenborn. (See no 116).

29 **Iris Tree** 1915
Oil on canvas
38¾ x 28 in
Signed and dated
Provenance: The Artist's Family
Exhibited: Alpine Club Gallery *Roger Fry, Paintings* 1915 no 4 (?); The
 Minories, Colchester *Paintings, Watercolours and Drawings of Roger
 Fry* 1959 no 10; Courtauld Institute Galleries *Portraits by Roger Fry*
 1976 no 15
Literature: Richard Shone *Bloomsbury Portraits* 1976 (pl 93); Frances
 Spalding *Roger Fry, Art and Life* 1980 (pl 80)

30 **Still Life with Blue Bottle** 1917
Oil on canvas
24½ x 17¾ in
Signed and dated
Exhibited: Mansard Gallery, Heal's *The New Movement in Art* 1917 no
 35; Leicester Museum & Art Gallery *C.A.S. Exhibition* 1919 no 15
Literature: Richard Morphet 'Roger Fry: the nature of his painting', *The
 Burlington Magazine* July 1980 p 486 (fig 26)

The blue bottle-shaped vessel could be one of the pottery pieces with a
dark blue cobalt glaze which Fry made for the Omega from 1915 onwards.
The background wall decorations give an indication of the mural style
which the Omega practised in its later years, showing a section of mottled
paintwork panels shaped like pilasters. A sienna wash of paint covers an
underpainting of stems, a design which relates to the decoration painted
on Mme Lalla Vandervelde's furniture (see no 117).

31 **Still Life with Italian Painting** 1918
Oil on panel
17 x 33 in
Provenance: The Artist's Family
Exhibited: *London Group Exhibition* 1918 no 2; The Minories, Colchester
 Paintings, Watercolours and Drawings of Roger Fry 1959 no 33; Arts
 Council *Vision and Design* 1966 no 83

An important painting summing up a certain phase in Roger Fry's work
and the two distinct parts of his life: the old master connoisseur and the
propagandist for new art and the Omega. This painting shows a
mantelpiece at Fry's Fitzroy Street studio covered with objects, indicating

the range of his interests in the spring of 1918. These include a 14th century Venetian Crucifixion (possibly by Paolo Veneziano), which Fry bought during the First World War, two pouches of precious, rationed tobacco, and a pot of Omega artificial flowers.

32 **Still Life with Omega Flowers** 1919
Oil on canvas
24 x 18 in
Signed and dated
Private Collection

Fry moved to Dalmeny Avenue, Camden Town in the spring of 1919; he painted the walls of his studio with vertical stripes of varying widths and hues – perhaps visible in the background of this painting. The foreground is filled with a large decorated black Omega pot containing four bizarre Omega artificial flowers.
See also nos 110, 111, 116-21, 127, 130, 133-35, 137-43, 147-63.

HENRI GAUDIER-BRZESKA (1891-1915)

33 **Vase: Water Carrier** 1913
Polished Marble
16½ x 4¾ x 3¾ in
Provenance: Ezra Pound
Private Collection
Exhibited: Alpine Club Gallery, *Second Grafton Group Exhibition*, 1914
 no 45
Literature: Roger Cole *Burning to Speak* Oxford 1978 p 98 (pl 45); Judith
 Collins *The Omega Workshops* 1984 (pl 22)

Gaudier-Brzeska became affiliated to the Omega Workshops in the autumn of 1913, soon after the defection of Lewis and his colleagues. In his list of sculptures compiled on 9th July 1914, he referred to this work as 'Vase' and noted the types of marble used; Sicilian for the separate pot at the top, and Seravezza for the figure. It was listed under Fry and Omega, and was to be sold with the Omega taking a 25% commission. This arrangement was the basis of Gaudier-Brzeska's association with the Omega Workshops. The idea of a caryatid figure supporting a bowl is one that Gaudier explored in his sculptures for the Omega; his garden statue maquettes for Lady Ian Hamilton have human and animal supporters.

Although Gaudier entered 'Vase' under 1914 in his list, it must have been completed by the end of 1913, since it was one of five sculptures he showed at Fry's Second Grafton Group Exhibition, which opened on 2nd January 1914. It was not sold at that exhibition, and by the time of Gaudier's death in June 1915, it was still in the possession of the Omega. Ezra Pound informed the New York collector John Quinn of Gaudier's death in July, and Quinn wrote back, asking Pound to buy all Gaudier's remaining work. Pound went to the Omega and put a deposit on a marble cat and this vase, which was by that point entitled *Water Carrier*. The *Vase: Water Carrier* was on sale at the Grafton Group for £20, and Pound was charged £42 10s for both the Vase and the Cat, so perhaps its price had risen slightly in the intervening months. The pose of the figure, with its knees drawn up and one arm raised to the head, is close to the wooden newel Gaudier designed for an Omega commission, illustrated in *The Burlington Magazine* of August 1916.

34 **Singing Woman: Design for Vase** 1913
Charcoal
15 x 10 in
Provenance: H. S. Ede

This drawing is probably related to an Omega decorative project. The design was not executed, but Gaudier did design a *Cat* which was produced in a limited edition from a mould (146). Fry may well have persuaded Gaudier to think of a sculpture which could be produced in an edition, and a ceramic work would be a suitable answer, being cheaper than bronze. Two works appear to lie behind the inception of this design: Gaudier himself carved a large figure of a *Singer* in 1913, which Ezra Pound believed was intended as a garden ornament, and the plaited hair of the *Singer* is close to the plait of the female figure in Epstein's *Maternity* 1911. Epstein produced several working drawings for *Maternity,* one of them showing a female figure in a curved posture with both hands placed on a hip, as here. On the verso of this sheet is an early version of Gaudier's *Design for a painted cupboard* (35).

35 **Design for a Painted Cupboard** 1913
Pencil
10⅛ x 15 in
Provenance: H. S. Ede

36 **Designs for an Omega Tray: The Wrestlers** 1913-14
Pencil and ink
14½ x 9 in
Provenance: H. S. Ede
Exhibited: Leicester Galleries *Memorial Exhibition of the Work of Henri Gaudier-Brzeska* 1918 no 102
Literature: Judith Collins *The Omega Workshops* 1984 (pl 26)

When Fry wrote an article on Gaudier-Brzeska, published in *The Burlington Magazine* of August 1916, in response to Ezra Pound's recently published *Memoir* of the sculptor, he included five photographs of work Gaudier had executed while associated with the Omega. One of these showed a marquetry tray, captioned by Fry *The Wrestlers* (Victoria & Albert Museum). These two designs are preliminary studies for the tray. Gaudier-Brzeska did numerous drawings of wrestlers from life, early in 1913, at the London Wrestling Club off Fleet Street. The tray was made for the Omega by John Joseph Kallenborn.

See also nos 123, 146.

ERIC GILL (1882-1940)

37 **Design for Bas-relief for the Cabaret Theatre Club** 1912
Pencil and watercolour, squared for transfer
9⅜ x 15¾ in
Exhibited: Anthony d'Offay *Eric Gill, Drawings and Carvings* 1982 no 9
Literature: Ashley Gibson *Postscript To Adventure* 1930 pp 104-5; Richard Cork 'The Cave of the Golden Calf', *Artforum* December 1982 pp 56-68 (reproduced)

Gill was commissioned to produce a bas-relief for the entrance of the Cabaret Theatre Club, the nightclub at 9 Heddon Street, run by Madame Frida Strindberg. The central room of the Club was christened the 'Cave of the Golden Calf' and a gilded stone calf was also carved by Gill as a centrepiece for the room. In the stone bas-relief, the figure of the calf was coloured.

CHARLES GINNER (1878-1952)

38 **Design for Tiger-hunting Mural in the Cabaret Theatre Club** 1912
Oil on board, squared for transfer
13½ x 22⅝ in
Provenance: The Artist
Literature: Richard Cork 'The Cave of the Golden Calf', *Artforum*
 December 1982 pp 56-68 (reproduced)

Ginner and Gore, along with Lewis, were asked by Madame Strindberg to
provide huge mural decorations for her Cabaret Theatre Club. The
central room, known as the Cave of the Golden Calf, had its walls hung
with large canvases by Gore and Ginner on the theme of hunting. Ginner
executed three separate works: *Chasing Monkeys,* over 8 by 6 feet, *Birds
and Indians,* 9 by 6 feet, and *Tiger-hunting,* which was in triptych form,
with the central panel 6 feet square. This study shows the whole triptych
of *Tiger-hunting,* and a contemporary photograph of the mural reveals
that this study is very close to the mural decoration as executed. The mural
itself is lost, as are the other two, and this study is the only remaining piece
of evidence for Ginner's contribution to the Cave of the Golden Calf.

SPENCER FREDERICK GORE (1878-1914)

39 **Design for Deer-hunting Mural in the Cabaret Theatre Club** 1912
Oil on paper, squared for transfer
11 x 24 in
Provenance: The Artist
Exhibited: Southampton Art Gallery *The Camden Town Group* 1951
 no 62; The Minories, Colchester *Spencer Gore 1878-1914* 1955 no 52
 (reproduced); Norwich Castle Museum *A Terrific Thing. British Art
 1910-1916* 1976 no 31
Literature: Wendy Baron *The Camden Town Group* 1979 no 117
 (reproduced); Richard Cork 'The Cave of the Golden Calf', *Artforum*
 December 1982 pp 56-68 (reproduced)

Of the surviving designs for the Deer-hunting mural, this is the closest in
configuration to the completed work, but Gore has altered the details of
ships and houses, making them more primitive in their final state and has
shown the hunters naked rather than clothed. The section of the sketch
with two ships at sea relates back to an earlier version, showing sailors
dancing, without animals or hunters.

40 **Design for Mural Decoration in the Cabaret Theatre Club** 1912

Oil on paper, squared for transfer

12 x 23¾ in

Provenance: The Artist; Mrs Malcolm Drummond

The Trustees of the Tate Gallery

Exhibited: Southampton Art Gallery *The Camden Town Group* 1951
no 61; The Minories, Colchester *Spencer Gore 1878-1914* 1955 no 50

Literature: Wendy Baron *The Camden Town Group* 1979 no 117; Simon
Watney *English Post-Impressionism* 1980 (pl 90); Richard Cork 'The
Cave of the Golden Calf', *Artforum* December 1982 pp 56-68

41 **Eight Studies for Decorations in the Cabaret Theatre Club** 1912

a) Pencil and crayon
10 x 14 in

b) Pencil, pen and ink and crayon
10 x 14 in

c) Pencil, pen and ink and crayon
10 x 14 in

d) Pencil and crayon
14 x 10 in

e) Pencil and watercolour
14 x 10 in

f) Pencil and crayon
12 x 10¾ in

g) Pencil and watercolour
3⅝ x 18⅛ in

h) Pencil, ink and watercolour
6 x 8 in

Provenance: The Artist

These drawings are some of the best evidence we have for the 'sensational'
appearance of the Cave of the Golden Calf.

DUNCAN GRANT (1885-1978)

42 **Pamela** 1911
Oil on canvas
20 x 30 in
Provenance: The Artist's Family
Exhibited: Grafton Galleries *Second Post-Impressionist Exhibition* 1912
 no 102; Mansard Gallery, Heal's, *The New Movement in Art* 1917; The
 Tate Gallery *Duncan Grant* 1959 no 18; The Minories, Colchester *The
 Camden Town Group* 1961 no 33; Rye Art Gallery *Artists of Bloomsbury*
 1967 no 4; Arts Council *Portraits by Duncan Grant* 1969 no 11;
 Scottish National Gallery of Modern Art, Edinburgh *Duncan Grant*
 1975 no 4; Royal Academy, London *Post Impressionism* 1979-80 no 303
 (reproduced)
Literature: P. G. Konody *The Observer* 27th October 1912; James Laver
 Portraits in Oil and Vinegar 1925 p 145; Raymond Mortimer *Duncan
 Grant* 1944 reproduced in colour pl 13; Richard Shone *Bloomsbury
 Portraits* 1976 p 79; New Brunswick, Canada, Beaverbrook Art Gallery
 Bloomsbury Painters and their Circle 1976 no 2; Richard Shone *The
 Post-Impressionists* 1979 pl 190; Frances Spalding *Roger Fry, Art and
 Life* 1980 pl 54; Simon Watney *English Post-Impressionism* 1980 p 88 pl 79

Painted in Summer 1911 in the garden of Roger Fry's house Durbins, near
Guildford, alongside Henri Doucet and Fry himself. The lilypond beside
which Fry's daughter posed later inspired a painted table and screen
produced by Grant for the Omega (nos 113 and 114).

43 **Study for Mural in J. M. Keynes' rooms, Webb's Court, King's
 College, Cambridge: Dancers and Grape-pickers** 1911
Oil on board
25¼ x 30 in
Inscribed on verso
Provenance: The Artist
Literature: Richard Shone *Bloomsbury Portraits* 1976 pp 72-3; Simon
 Watney *English Post-Impressionism* 1980 p 88 pl 80

In late 1911 Maynard Keynes commissioned Grant to decorate his study
in Webb's Court, King's College, Cambridge, and Grant envisaged a
scheme of grape-pickers and dancers. He designed four panels to be
positioned above the dado; this study is for the second panel, which

together with the third portrays male dancers joining hands to form a circle. The first and fourth panels depicted grape-pickers with large baskets on their heads. The theme of the Webb's Court mural is closely related to Grant's easel painting at this time; the *Lemon Gatherers* (early 1910, Tate Gallery) shows fruit-pickers with large baskets on their heads, and the *Dancers* (late 1910-early 1911, Tate Gallery) which exists in two versions, shows five female dancers linking hands in a circle.

The mural itself, though considerably advanced, was left unfinished in early 1912 and ten years later was covered with new decorations by Grant and Vanessa Bell (see no 78).

44 **Design for Macbeth Table Vase** 1912
Pencil and watercolour
20 x 15 in
Provenance: The Artist's Family
Literature: Bluecoat Gallery, Liverpool *Duncan Grant, Designer* 1980 no
 93

In April 1912 the producer and actor, Harley Granville-Barker, commissioned Duncan Grant to design the costumes and properties for a production of *Macbeth* in a Shakespeare season at the Kingsway Theatre. The artist Norman Wilkinson was to design the scenery. It was the first of Grant's several commissions for the theatre. The collaboration, however, broke down in 1913 and Grant withdrew, allowing Wilkinson to use or adapt his designs as he thought fit. Many drawings for the costumes exist, influenced by the Byzantine style of dress, as seen, for example, in the Ravenna mosaics. This design and no 45 are for the table in the banquet scene (Act III Scene 3). Before Grant had completed his commission, the French producer Jacques Copeau had asked him to design a production of *Twelfth Night* for the Théâtre du Vieux Colombier in Paris (a request that coincided more sympathetically with Grant's talents). In this production several Omega linens were used for the costumes.

45 **Design for Macbeth Table Vase** 1912
Pencil and watercolour
20 x 15 in
The Charleston Trust

46 **Eight Designs for Omega Pottery** 1912-13
Pencil
Each 16½ x 13¼ in
Provenance: The Artist's Family

Grant made no pottery for the Omega Workshops, although he decorated commercially-bought ware and pots thrown by Fry. The stark simplicity

of these drawings relates to Grant's 1912 designs for *Macbeth* (see 44 and 45) and the unadorned shapes of Fry's pottery of *c.* 1915. It seems likely that they were ideas for ceramics, swiftly executed on one block of paper, to contribute to the portfolio or 'bank' of designs kept at the Workshops.

47 **On the Roof, 38 Brunswick Square** 1912
Oil on wood
38 x 47 in
Exhibited: Anthony d'Offay *Duncan Grant, Early Paintings* 1975;
 Scottish National Gallery of Modern Art, Edinburgh *Duncan Grant*
 1975 no 9; Fine Art Society, Edinburgh *Bloomsbury Portraits* 1976 no
 35
Literature: Richard Shone *Bloomsbury Portraits* 1976 (reproduced in
 colour pl I)

This painting shows (left to right) Virginia Stephen, her brother Adrian, and her future husband Leonard Woolf (whom she married in August 1912) on the mezzanine roof at the back of 38 Brunswick Square, a house they shared at this time with Duncan Grant and J. M. Keynes. Painted in 'Duncan's leopard manner' (see note to no 2). The painting has in the past been ascribed to Frederick Etchells. Both Grant and Etchells often worked together at this time and in style they were sometimes almost indistinguishable from one another.

48 **Design for Firescreen** 1912
Gouache on paper
29 x 23¾ in
Signed and dated
Provenance: The Artist's Family
Exhibited: Fine Art Society *Bloomsbury Portraits* 1976 no 37
Literature: Quentin Bell *Bloomsbury* 1974 (reproduced between pp 48-
 49); Isabelle Anscombe *Omega and After* 1981 (firescreen reproduced
 in colour pl I); Judith Collins *The Omega Workshops* 1984 (reproduced
 in colour pl III)

The most fully worked of Grant's three designs for firescreens using the image of a vase of flowers and pair of brightly coloured birds; the idea first appears on the back of an envelope of autumn 1912. It was embroidered in silk by Lady Ottoline Morrell; an intermediate design in pastel is in the Courtauld Institute collection. Another version was also used for the cross-stitch panel of a chair-back for sale at the Omega Workshops in 1913. Both Vanessa Bell's *Design for a Screen* (1), and this design predate the Omega Workshops by several months.

49 **Group at Asheham** 1913
Oil on board
10½ x 25 in
Signed, dated and inscribed
Provenance: The Artist's Family
Literature: John Lehmann *Virginia Woolf and her World* 1975
 (reproduced p 31)

A group on the terrace at Asheham House, Sussex showing (left to right)
Adrian Stephen, Virginia Woolf (reading), Vanessa Bell and Henri
Doucet. Probably painted in July or August 1913.

50 **Ass with Birds** 1913
Pencil and watercolour
11¼ x 17½ in
Signed with initials
Provenance: The Artist's Family

This hybrid creature appears in various forms in Grant's decorative work
of 1913-14: as an embroidery design (Courtauld Institute Galleries), as a
book plate in monotype for Lady Strachey (1914) and fully adapted in dye
paints on cushion covers for the Omega in 1913. It is a near relation of
Grant's painting *The Ass* of which two 1913 versions exist.

51 **Head of Eve** 1913
Oil on board
29¾ x 25 in
Provenance: David Garnett
Exhibited: Whitechapel Art Gallery *Painters' Progress* 1950 no 8;
 Scottish National Gallery of Modern Art, Edinburgh *Duncan Grant*
 1975 no 12
Literature: Roger Fry *Duncan Grant* 1924 pl 8

A study for a large painting of *Adam and Eve,* commissioned in 1913 by
Clive Bell for the C.A.S. and exhibited at the Second Grafton Group
exhibition in January 1914. (It was later destroyed after being damaged in
the Tate Gallery flooding in 1928.)

52 **Cyclamen** 1913
Oil on board
29¼ x 24¾ in
Provenance: The Fry Family, Pamela Harris
Exhibited: Browse & Darby *British Paintings* 1978 no 15 (reproduced in
 colour on catalogue cover)

Two versions are known of *Cyclamen,* this one and a paler, more linear
one which was shown at the Second Grafton Group exhibition, at the
Alpine Club Gallery, January 1914, where it was bought by Roger Fry's
sister, Margery.

53 **Omega Design: Bathers** 1913-14
Pastel and pencil
7¾ x 14¼ in
Provenance: Roger Fry

54 **Omega Design: Abstract** 1913-14
Pastel and pencil
7 x 14 in
Provenance: Roger Fry

55 **Omega Design: Candles and Figures** 1913-14
Pastel and pencil
14 x 7¼ in
Provenance: Roger Fry

56 **Vanessa Bell in a Sun Hat, Asheham** 1914
Oil on canvas
13¼ x 10 in
Provenance: The Artist
Exhibited: Fine Art Society *Bloomsbury Portraits* 1976 (ex catalogue)

57 **Standing Nude with Bird** 1914
Oil on wood
72 x 24¼ in
Provenance: The Artist

One of four decorative panels of the same size, all depicting female nudes (see also no 58). This figure is taken directly from a photograph of Molly MacCarthy, standing in Vanessa Bell's studio at 46 Gordon Square in about 1913 or 1914. *Blue Nude with Flute* (58) shows Lytton Strachey's sister Marjorie, with a pug dog. The two other panels were both of a standing nude, one of them Marjorie Strachey (with, on verso, the mountaineer George Mallory).

58 **Blue Nude with Flute** 1914
Oil on panel
24½ x 72 in
Provenance: The Artist

See note to no 57.

59 **The Modelling Stand** 1914
Oil and *papier collé* on board
29¾ x 24¾ in
Provenance: The Artist
Exhibited: Bluecoat Gallery, Liverpool *Duncan Grant, Designer* 1980 no 26

This is one of Grant's largest and most elaborate collages, it is also one of the first works in which he used *papier collé*. The work can be dated to 1914 on stylistic evidence and from its similarity with the Tate Gallery's *The Mantelpiece* of *c*. 1914, which Grant regarded as one of his first collage paintings.

60 **On the Mantelpiece: Omega Paper Flowers** 1914-15
Oil on canvas
21¾ x 29½ in
Provenance: Adrian Stephen

Paper flowers made by Vanessa Bell, Winifred Gill and others were regularly on sale at the Omega from 1914 and appear in several still lifes by Fry, Bell and Grant. The flowers were made from stiffened tarlatan, which was dyed in strong, pure colours, with decorative details added in coloured wools. This work (for which a study in oil for the left side exists in a London private collection) was probably painted at Asheham House or in Grant's Fitzroy Street studio.

61 **Still Life with Fruit and Coffee Pot** 1914
Pencil, oil and *papier collé* on panel
18½ x 25½ in
Signed and dated
Provenance: Lord and Lady Rennell of Rodd

'Duncan has been doing most lovely Still-Lifes besides his long roll',
Vanessa Bell wrote to Fry from Asheham House (1 September 1914). The
'long roll' refers to Grant's most ambitious abstract work, his *Abstract
Kinetic Collage Painting with Sound* 1914 (Tate Gallery), and the 'Still-
Lifes' are undoubtedly a group of paintings, some of which, like the
present work, employ *papier collé*. All depict domestic objects on table
tops clustered around a large central constituent, such as a lamp, tea pot
or, as in this case, a French lustre coffee pot. Those with collage employ
either plain-coloured or patterned paper on clear paper first fixed to the
support and then painted in accordance with the work's pictorial needs.

62 **The Omega Hat** *c.* 1915
Pen and ink
11¾ x 7¾ in
Provenance: The Artist

Several hat designs by Grant exist; some were made up and sold from the
dress-making department of the Omega Workshops. Iris Tree, Mary
Hutchinson and Lady Ottoline Morrell were among the purchasers of
these sometimes fantastic items, hand-painted with dyes by the Omega
artists. A further group was designed by Grant (see no 75), just before the
closure of the Workshops in 1919, one of which was commissioned by
Virginia Woolf. 'What do I owe for my hat?' she asked Vanessa Bell (on
29th June 1919). Hats and head-dresses appear frequently in Grant's work
as both designer and portrait painter – from the turbans of 1910-1911 to a
variety of sunhats (see *Vanessa Bell in a Sun Hat* no 56). His most
flamboyant were designed for actors in Jacques Copeau's production of
Twelfth Night, Paris, 1914.

63 **Mary St John Hutchinson** 1915
Oil on board
27 x 20 in
Provenance: The Artist

Painted at the same time as two portraits of Mary Hutchinson by Vanessa
Bell (see no 14). The painting confirms that the decorative rectangular

form in the background of the Bell portrait actually existed in the room in which Mary Hutchinson sat, at 46 Gordon Square. Grant, sitting a few feet to Vanessa Bell's left, has also included the corner of another abstract design, at the right of his composition.

64 **Omega Design for a Rug** 1913-14
Pencil and watercolour
8⅛ x 10½ in
Literature: Judith Collins *The Omega Workshops* London 1984
pl 60

65 **Abstract Composition** 1915
Oil on canvas
25¾ x 47¾ in
Provenance: The Artist's Family

Private Collection

Although this painting has features similar to Omega designs (its rug format and tent-like segments), it was intended as a painting in its own right and is listed as such in Vanessa Bell's 1951 inventory of pictures at Charleston.

66 **Abstract** 1915
Papier collé
17¼ x 30 in
Provenance: The Artist

67 **Abstract Design** 1915
Pencil
10½ x 8¼ in
Provenance: The Artist

The interrupted verticals and linear tent shape are a frequent compositional device in Grant's non figurative works (see nos 68, 69 and 72) and in Grant's and Vanessa Bell's still-lifes, as early as 1913. In the figurative works the motif can often be discerned as the overlapping structures of two or more easels; in other paintings as triangular tent forms, in Vanessa Bell's Omega screen *Bathers in a Landscape* (Victoria & Albert Museum), for example, and Grant's *Tents* 1913 (Private Collection).

68 **Abstract** 1915
Oil and collage on panel
24¾ x 17¾ in
Provenance: The Artist

Grant's use of collage (which includes fabrics, bottle labels, silver and marbled paper, glued wood, as well as *papier collé*) occurs in his easel paintings between mid-1914 and 1916 and coincides with most of his abstract or near-abstract works. When the Vorticists invited Grant to exhibit at their London exhibition in June 1915, he sent a 'Still Life' and two 'Paintings', both non-figurative with attached pieces of firewood, and probably similar in content and method to the present work.

69 **In Memoriam: Rupert Brooke** 1915
Oil and collage on panel
21¾ x 12 in

Provenance: The Artist

Exhibited: Scottish National Gallery of Modern Art, Edinburgh *Duncan Grant* 1975 no 19; Tate Gallery *Abstraction: Towards a New Art* 1980 no 409 (reproduced)
Literature: R. Shone *Bloomsbury Portraits* 1976 p 142 pl 89; Simon Watney *English Post-Impressionism* 1980 p 98, and note 17

Grant painted this picture in memory of Rupert Brooke who died on 23rd April 1915, and of his younger brother Alfred, who had been killed in action a month earlier.

70 **Still Life: The Glass** 1915-16
Oil on canvas
10 x 14 in
Provenance: The Artist's Family

From the spring of 1916, Grant – because he was a conscientious objector – worked as a fruit farmer and labourer. There was little time for painting, but a number of small still lifes probably date from this year. The objects in this work and in *Still Life with White Bowl* (71) appear in several works of this period.

71 **Still Life with White Bowl** 1916
Oil on canvas
12 x 14 in
Provenance: The Artist's Family

See note to no 70.

72 **Composition with Flower and Glass** 1916-17
Oil on canvas
14¼ x 12¼ in
Provenance: The Artist's Family

See note to no 67.

73 **Decorative Design** 1916-17
Oil on paper laid on board
24⅝ x 19⅛ in
Signed and inscribed on verso
Provenance: David Garnett
Literature: Judith Collins *The Omega Workshops* 1984 (reproduced in
 colour pl VIII)

74 **Studies for Omega Designs** *c.* 1918
Pen and ink
10 x 8 in
Provenance: The Artist

These designs were possibly intended for bedheads (see nos 11 and 20).

75 **Design for an Omega Hat** *c.* 1919
Pencil
10¾ x 9½ in
Provenance: The Artist

See note to no 62.

76 **Flowers in a Glass Vase** 1918-19
Oil on panel
23 x 21 ¼ in
Provenance: The Artist's Family

Part of a decorative scheme, perhaps for a cupboard door.

77 **Still Life at Charleston** *c*. 1919
Oil on canvas
20 x 30 in
Provenance: The Artist's Family
Exhibited: Fine Art Society, Edinburgh *Duncan Grant and Bloomsbury*
 1975 no 10

Painted in Vanessa Bell's studio at Charleston, after a careful preparatory
drawing. The door to the right carries four painted panels by Duncan
Grant (*c*. 1918), showing two caryatid figures in the upper panels, a male
and a female with large baskets of fruits on their heads, and in the lower
panels, more fruit baskets. The paintings are still *in situ*. The room was
later Clive Bell's library.

78 **Eight Studies for Murals in J. M. Keynes' rooms, Webb's Court,
King's College, Cambridge** 1920
Oil on canvas
each 33 x 14½ in
Exhibited: Bluecoat Gallery, Liverpool *Duncan Grant, Designer* 1980 no
 45 (2 panels); Edward Harvane Gallery *A Homage to Duncan Grant*
 1975 no 7 (one panel)
Literature: Dorothy Todd and Raymond Mortimer *The New Interior
 Decoration* 1929 pl 24 and 25; Milo Keynes 'The Picture Collector'
 Essays on John Maynard Keynes 1975 p 286; Richard Shone
 Bloomsbury Portraits 1976 pp 234-5

The closing of the Omega did not mean an end to collaborative schemes
for decoration, and Grant and Vanessa Bell undertook many over the
following years. In 1918 they had decorated Maynard Keynes' sitting
room at 46 Gordon Square and in the summer of 1920 at Charleston, they
began work on eight panels (5 by two feet 6 inches each), four by each
artist. They supposedly represented the muses of 'Law, Science, History
etc. though you mightn't think it', Vanessa Bell told Fry – 'in fact we are
always changing their arts and sciences' (letter of 26th August 1920). Four

of the panels covered Grant's earlier mural (see no 43) of 1911-12; the main door of the room divided the panels which, along with the appliqué curtains and suitable furniture, were eventually installed by 1922.

See also nos 112-14, 122, 124, 129-31, 136, 145.

CUTHBERT HAMILTON (1884-1959)

79 **Three Dancing Figures** 1912-13
Ink
12¾ x 21¼ in
Provenance: Agnes Bedford
Exhibited: Arts Council *Vorticism and its Allies* 1974 no 75
Literature: Richard Cork *Vorticism and Abstract Art in the First Machine Age* 1976 p 37 (reproduced)

Cuthbert Hamilton was a contemporary of Wyndham Lewis at the Slade from 1899 to 1901. They met again when Lewis was working on his Cabaret Theatre Club murals and screens in the early summer of 1912. A letter from Lewis to Hamilton at this time seems to indicate that Hamilton assisted him on a shadow-play project there, and that possibly Hamilton did some work of this nature on his own. This drawing shows two figures on the left in what could be read as eighteenth century costume, while the third figure on the right, a female with long hair who throws her head and arms backwards, seems only to be wearing trousers and boots. The Cabaret Theatre Club offered performances of early Mozart operas, so an eighteenth century feel to these figures is not without some relevance. (Etchells also executed a painting in 1912-13 of *Three Figures in Eighteenth Century Costume* (Towner Art Gallery, Eastbourne)). Hamilton was invited by Fry to exhibit along with the Grafton Group in March 1913, and he then worked at the Omega from July to the beginning of October when he left with Lewis. Little is known of his contribution to the Omega. He joined Lewis's Rebel Art Centre in the spring of 1914 and was one of the signatories to the Vorticist manifesto in *Blast No. 1*.

See also no 144.

MIKHAIL LARIONOV (1881-1964)

80 **Homage to Roger Fry** 1919
Watercolour and collage
10 x 7⅞ in
Signed and dated
Provenance: Roger Fry
Exhibited: Arts Council *Vision and Design* 1966 no 34

Fry, at the suggestion of Boris Anrep, included a section of Russian art in his Second Post-Impressionist Exhibition, and Larionov was represented by one canvas, *The Soldiers*. Larionov joined Diaghilev in Paris in 1914, and designed the costumes and sets for several Ballets Russes. Fry's first experience of a Larionov ballet came in November 1918 when the Russian Ballet presented *Le Soleil de Minuit* at the Coliseum. In December, his *Contes de Fées* was also performed at the Coliseum, and Fry wrote of it as 'the most lovely spectacle that I've ever seen on the stage . . .'. Fry and Larionov became good friends and Fry gave Larionov an exhibition of his stage designs at the Omega Workshops in February 1919. It consisted of eleven works on paper, and was his first one-man show in Britain. Fry wrote an article 'M. Larionov and the Russian Ballet', published in *The Burlington Magazine* of March 1919.

PERCY WYNDHAM LEWIS (1882-1957)

81 **Centauress No 2** 1912
Pencil, ink, crayon and gouache
12⅜ x 9⅜ in
Signed and dated
Exhibited: Redfern Gallery *Wyndham Lewis* 1949 no 22; National Book League *Word and Image I & II, Wyndham Lewis and Michael Ayrton* 1971 no 5; Anthony d'Offay *Wyndham Lewis, Drawings and Watercolours 1910-1920* 1983 no 6 (reproduced)
Literature: Charles Handley-Read *The Art of Wyndham Lewis* 1951 p 85; Walter Michel *Wyndham Lewis, Paintings and Drawings* 1971 no 42 pl 5

A centauress is a unique invention of Lewis, and the creature in this design is an aggressive and mobile female, with outstretched grasping hands. In

the Second Post-Impressionist Exhibition in the winter of 1912, Lewis showed a work entitled *Amazons*, and throughout 1912 seems to have shown a liking for depicting female warriors.

82 **Two Figures** 1912
Pencil, ink, crayon and gouache
12¼ x 9½ in
Signed and dated
Exhibited: Anthony d'Offay *Wyndham Lewis, Drawings and Watercolours 1910-1920* 1983 no 7 (reproduced)
Literature: Walter Michel *Wyndham Lewis, Paintings and Drawings* 1971 no 112

In June 1912, P. G. Konody, the art critic of *The Observer* reported that the artists associated with the decoration of the Cave of the Golden Calf were known as The Troglodytes or Cave-dwellers. Possibly these figures are Lewis's variations on the subject of cave-dwellers.

83 **Man and Woman** 1912
Pencil, ink, crayon and gouache with collage
14⅝ x 10 in
Signed and dated
Exhibited: Redfern Gallery *Wyndham Lewis* 1949 no 36; Tate Gallery *Wyndham Lewis and Vorticism* 1956 no 14; Anthony d'Offay *Wyndham Lewis, Drawings and Watercolours 1910-1920* 1983 no 9 (reproduced)
Literature: Charles Handley-Read *The Art of Wyndham Lewis* 1951 p 84 pl 2; Walter Michel *Wyndham Lewis, Paintings and Drawings* 1971 no 75 pl 5

84 **Two Vorticist Figures** 1912
Pencil, ink and gouache
9⅞ x 12½ in
Signed
Exhibited: Anthony d'Offay 1983 no 12 (reproduced)
Literature: *Agenda* Wyndham Lewis Special Issue, Autumn-Winter 1969-70 pl 8; Walter Michel *Wyndham Lewis, Paintings and Drawings* 1971 no 116 pl 12

85 **Futurist Figure** 1912
Pencil, ink and watercolour
10⅜ x 7¼ in
Provenance: Helen Saunders
Exhibited: Anthony d'Offay 1983 no 13 (reproduced)
Literature: Walter Michel *Wyndham Lewis, Paintings and Drawings*
 1971 no 67 pl 21

86 **Design for Drop-Curtain for the Cabaret Theatre Club** 1912
Pencil, ink and crayon
12 x 15¼ in
Signed, dated and inscribed on verso

Theatre Museum, Victoria & Albert Museum
Exhibited: Anthony d'Offay *Wyndham Lewis, Drawings and
 Watercolours 1910-1920* 1983 no 4 (reproduced in colour)
Literature: Richard Cork 'The Cave of the Golden Calf', *Artforum*
 December 1982 pp 58-68 (reproduced in colour)

The design is close to another 1912 work by Lewis, known both as *Indian
Dance* and *Ballet Scene* (Tate Gallery).

87 **Figures with Horses** 1912
Pencil, ink and gouache
9¼ x 12¼ in
Signed
Provenance: Charles Handley-Read
Exhibited: Redfern Gallery *Wyndham Lewis* 1949; Tate Gallery
 Wyndham Lewis and Vorticism 1956 no 18; Anthony d'Offay 1983 no
 10
Literature: Walter Michel *Wyndham Lewis, Paintings and Drawings*
 1971 no 61 pl 6

The central figure holds a whip in its left hand and horses' reins in its right.
The head of one horse with its long neck and mane towers above the figure
on the left. Another horse, of a darker hue, stands directly behind it. The
head and neck of a third have been obliterated by a wash of gouache across
the top right-hand area of the drawing. Lewis also used the theme of circus
performers and horses (which appears all through European art of this
time) in the *Design for Drop-Curtain for the Cabaret Theatre Club* (86)
and in *Cabaret Theatre Scene* (90).

88 **Timon of Athens** 1912
Half tone and line engraving
Sixteen sheets each measuring 15¼ x 10⅝ in
Literature: Richard Aldington, review of the portfolio in *The Egoist*
 1 January 1914; Walter Michel *Wyndham Lewis, Paintings and
 Drawings* 1971 nos 91-108 pl 17-20

The original drawings, now lost, were exhibited in the Second Post-
Impressionist Exhibition at the Grafton Galleries from October to
December 1912. They were privately published in a printed portfolio in
December 1913 by 'The Cube Press', a pseudonym for the artist. Few
copies of this, Lewis's first separate publication, survive.
 Shakespeare's hero's rejection of society in *Timon of Athens* must have
appealed to Lewis. Having retired to live in a cave, Timon holds
discussions on poetry and the arts.

89 **Nine Designs for Lampshades** 1913
Line engraving
Each image 5¼ x 11⅛ in
Provenance: Duncan Grant
Exhibited: Miller's, Lewes *The Omega Workshops* 1946 no 37
Literature: Walter Michel *Wyndham Lewis, Paintings and Drawings*
 1971 nos 132-140 (no 138 pl 27); Quentin Bell *Bloomsbury* 1974 (one
 reproduced between pp 48-49); Richard Cork *Vorticism and Abstract
 Art in the First Machine Age* p 88 (one reproduced); Judith Collins *The
 Omega Workshops* 1984 (one reproduced pl 10)

Although most of the Omega lampshades had abstract designs, Lewis
produced a range of figurative images. Winifred Gill was apparently told
by Lewis that some of these represented 'stages in the bargaining between
a *roué* and a procuress for the purchase of a young woman'. Two of the
designs shown here depict circus performers, in a style close to the screen
on the same subject which Lewis painted at the Omega in June and July
1913. (See photograph on page 14.)

90 **Cabaret Theatre Scene** 1913-14
Ink and watercolour
9⅜ x 12½ in
Signed and dated 1913 and 1914
Provenance: Edward Wadsworth
Exhibited: Tate Gallery *Wyndham Lewis and Vorticism* 1956 no 37;
 Anthony d'Offay *Wyndham Lewis, Drawings and Watercolours 1910-
 1920,* 1983 no 15 (reproduced)
Literature: Walter Michel *Wyndham Lewis, Paintings and Drawings*
 1971 no 160 pl 24

The subject of *Cabaret Theatre Scene* shows the circus from a
combination of different viewpoints, bringing together the circus ring, the
whip-cracking ringmaster, the horses, the tent, a clown, a juggler or
acrobat and two female performers. See also no 87.

91 **Dancing Figures** 1914
Pencil, ink, crayon, gouache and oil
8¼ x 19¾ in
Signed with initials and dated
Exhibited: Anthony d'Offay *Wyndham Lewis, Drawings and
 Watercolours 1910-1920* 1983 no 16 (reproduced in colour)

It has been suggested that this is a design for the Rebel Art Centre or the
Restaurant de la Tour Eiffel. The elongated proportions of the work
intimate that it was done with a particular site in mind, possibly above a
door. Lewis hung a large painting of dancing ladies (approximately 34 by
57 in) over the door of the dining room he decorated for the Countess of
Drogheda early in 1914. Photographs of the Rebel Art Centre also show a
work hung above a door.

92 **Spanish Dance** 1914
Ink, watercolour and gouache with collage
15 x 11 in
Signed, dated and inscribed 'Spanish dance'
Provenance: The Artist
Exhibited: Anthony d'Offay *Wyndham Lewis, Drawings and
 Watercolours 1910-1920* 1983 no 17
Literature: Walter Michel *Wyndham Lewis, Paintings and Drawings*
 1971 no 172 pl 25; Wyndham Lewis *The Complete Wild Body* Black
 Sparrow Press 1982 (reproduced p 257)

93 **Vorticist Design** 1914
Crayon, ink and gouache
10¼ x 8 in
Signed
Provenance: H. T. Tucker, Omar Pound
Exhibited: Arts Council *Vorticism and its Allies* 1974 no 256; Manchester
City Art Gallery *Wyndham Lewis* 1980 no 34 (reproduced); Anthony
d'Offay 1983 no 18 (reproduced)
Literature: Walter Michel *Wyndham Lewis, Paintings and Drawings*
1971 no 158; Richard Cork *Vorticism and Abstract Art in the First
Machine Age* 1976 p 328 (reproduced)

94 **Abstract: Horse** 1914
Ink
12⅞ x 9⅛ in
Signed and dated
Provenance: The Artist
Exhibited: Arts Council *Vorticism and its Allies* 1974 no 257; Anthony
d'Offay *Wyndham Lewis, Drawings and Watercolours 1910-1920* 1983
no 19 (reproduced)
Literature: Walter Michel *Wyndham Lewis, Paintings and Drawings*
1971 no 157 pl 31

The origin of the format of this extremely stylised rearing horse can be
found in Lewis's *Cabaret Theatre Scene* (no 90). The same configuration
of shoulder, neck and head can be seen, on a greatly reduced scale in the
horse at the very bottom left.

95 **Timon of Athens** 1913-14
Pencil, ink and wash
13½ x 10⅜ in
Signed
Provenance: Ezra Pound
Exhibited: Anthony d'Offay *Abstract Art in England 1913-15* 1969 no 41
(reproduced); Arts Council *Vorticism and its Allies* 1974 no 252;
Davis & Long, New York *Vorticism and Abstract Art in the First
Machine Age* 1977 no 63; Palazzo Reale, Milan *Origini dell'Astrattismo*
1979-80 no 398 (reproduced); Tate Gallery *Towards a New Art* 1980 no
376 (reproduced); Anthony d'Offay *Wyndham Lewis, Drawings and
Watercolours 1910-1920* 1983 no 20
Literature: *Blast No 1* July 1914 (reproduced p v); Walter Michel
Wyndham Lewis, Paintings and Drawings 1971 no 154 pl 22; Richard
Cork *Vorticism and Abstract Art in the First Machine Age* 1976 p 129
(reproduced)

96 **Composition I** 1914-15
Pencil, ink, crayon and watercolour
12¾ x 10¼ in
Signed and dated
Provenance: Michael Ayrton

Exhibited: Anthony d'Offay *Abstract Art in England 1913-15* 1969 no 46
(reproduced); National Book League *Word and Image I & II,
Wyndham Lewis and Michael Ayrton* 1971 no 11; Arts Council
Vorticism and its Allies 1974 no 261; Davis & Long, New York *Vorticism
and Abstract Art in the First Machine Age* 1977 no 65; Anthony d'Offay
Wyndham Lewis, Drawings and Watercolours 1910-1920 1983 no 24
(reproduced)

Literature: Walter Michel *Wyndham Lewis, Paintings and Drawings*
1971 no 176 pl 28; Richard Cork *Vorticism and Abstract Art in the First
Machine Age* 1976 p 415 (reproduced)

97 **Composition II** 1914
Pencil and watercolour
12 x 10¼ in

Exhibited: Anthony d'Offay *Abstract Art in England 1913-15* 1969 no 47;
Arts Council *Vorticism and its Allies* 1974 no 262; Yale Center for
British Art, New Haven *Blast: The British Answer to Futurism* 1982
no 4

Literature: Walter Michel *Wyndham Lewis, Paintings and Drawings*
1971 no 178; Richard Cork *Vorticisim and Abstract Art in the First
Machine Age* 1976 p 345 (reproduced in colour)

98 **Composition III** 1914-15
Pencil and watercolour
11½ x 10½ in

Exhibited: Anthony d'Offay *Abstract Art in England 1913-15* 1969 no 48;
Arts Council *Vorticism and its Allies* 1974 no 263

Literature: Walter Michel *Wyndham Lewis, Paintings and Drawings*
1971 no 180; Richard Cork *Vorticism and Abstract Art in the First
Machine Age* 1976 pl 339 (reproduced in colour)

99 **Composition IV** 1914-15
Pencil
11½ x 10 in
Exhibited: Anthony d'Offay *Abstract Art in England 1913-15* 1969 no 49;
 Arts Council *Vorticism and its Allies* 1974 no 264; Yale Center for
 British Art, New Haven *Blast: The British Answer to Futurism* 1982
 no 5
Literature: Walter Michel *Wyndham Lewis, Paintings and Drawings*
 1971 no 181; Richard Cork *Vorticism and Abstract Art in the First
 Machine Age* 1976 p 344 (reproduced)

100 **Composition V** 1914-15
Pencil
12⅛ x 9⅞ in
Exhibited: Anthony d'Offay *Abstract Art in England 1913-15* 1969 no 50;
 Arts Council *Vorticism and its Allies* 1974 no 265
Literature: Walter Michel *Wyndham Lewis, Paintings and Drawings*
 1971 no 186; Richard Cork *Vorticism and Abstract Art in the First
 Machine Age* 1976 p 338 (reproduced)

101 **Composition VI** 1914-15
Pencil
14⅛ x 9⅞ in
Exhibited: Anthony d'Offay *Abstract Art in England 1913-15* 1969 no 51;
 Arts Council *Vorticism and its Allies* 1974 no 267
Literature: Walter Michel *Wyndham Lewis, Paintings and Drawings*
 1971 no 183; Richard Cork *Vorticism and Abstract Art in the First
 Machine Age* 1976 p 340 (reproduced)

102 **Composition VII** 1914-15
Pencil
12¼ x 10¼ in
Exhibited: Anthony d'Offay *Abstract Art in England 1913-15* no 52; Arts
 Council *Vorticism and its Allies* 1974 no 268
Literature: Walter Michel *Wyndham Lewis, Paintings and Drawings*
 1971 no 182

103 **Composition VIII** 1914-15
Pencil
12 x 9⅞ in
Exhibited: Anthony d'Offay *Abstract Art in England 1913-15* 1969 no 53;
 Arts Council *Vorticism and its Allies* 1974 no 269
Literature: Walter Michel *Wyndham Lewis, Paintings and Drawings*
 1971 no 184; Richard Cork *Vorticism and Abstract Art in the First
 Machine Age* 1976 p 340 (reproduced)

104 **Red Duet** 1914
Crayon and gouache 15 x 22 in
Signed and dated
Provenance: Ezra Pound
Exhibited: Doré Galleries *Vorticist Exhibition* 1915; Anthony d'Offay
 Abstract Art In England 1913-15 1969 no 44 (reproduced in colour on
 cover); Arts Council *Vorticism and its Allies* 1974 no 258
 (reproduced); Davis & Long, New York *Vorticism and Abstract Art in
 the First Machine Age* 1977 no 64; Tate Gallery *Abstraction: Towards a
 New Art* 1980 no 378 (reproduced); Anthony d'Offay *Wyndham Lewis,
 Drawings and Watercolours* 1983 no 21 (reproduced)
Literature: *Agenda* Wyndham Lewis Special Issue, Autumn-Winter
 1969-70 pl 15; Walter Michel *Wyndham Lewis, Paintings and
 Drawings* 1971 no 170 pl 28; Richard Cork *Vorticism and Abstract Art
 in the First Machine Age* 1976 (reproduced in colour p 337); Richard
 Shone *The Century of Change, British Painting since 1900* 1977
 (reproduced in colour pl 55); Norbert Lynton *The Story of Modern Art*
 Oxford 1981 (reproduced in colour pl 80)

105 **Design for Red Duet** 1915
Pencil, ink watercolour and gouache
12½ x 9¾ in
Signed with initials and dated
Provenance: John Quinn
Exhibited: Doré Galleries *Vorticist Exhibition* 1915 no 5a (reproduced as
 frontispiece to the catalogue); Penguin Club, New York *Exhibition of
 the Vorticists at the Penguin* 1917 no 27; Anthony d'Offay *Wyndham
 Lewis, Drawings and Watercolours* 1983 no 22 (reproduced)
Literature: *Blast No 2* July 1915 p 63 (reproduced); Walter Michel
 Wyndham Lewis, Paintings and Drawings 1971 no 204 pl 26; Arts
 Council *Vorticism and its Allies* 1974 no 259; Richard Cork *Vorticism
 and Abstract Art in the First Machine Age* 1976 p 336 (reproduced)

106 **Workshop** 1914-15

Oil on canvas

30 x 24 in

The Trustees of the Tate Gallery

Provenance: John Quinn; Anthony d'Offay

Exhibited: Goupil Gallery, *Second London Group Exhibition*, 1915 no 85; Doré Galleries *Vorticist Exhibition* 1915 no 6; Penguin Club, New York *Exhibition of the Vorticists at the Penguin* 1917 no 36; Arts Council *Vorticism and its Allies* 1974 no 276 (reproduced); Tate Gallery *Abstraction: Towards a New Art* 1980 no 381 (reproduced)

Literature: Quinn Sale Catalogue 1927 no 353; Walter Michel *Wyndham Lewis, Paintings and Drawings* 1971 no P19 pl 30; Richard Cork *Vorticism and Abstract Art in the First Machine Age* 1976 (reproduced in colour p 343); Tate Gallery 1974-1976, *Illustrated Catalogue of Acquisitions* 1978 pp 122-124; Richard Shone *The Century of Change, British Painting since 1900* 1977 pl 48

In 1914 Lewis produced an abstract coloured drawing (which has the title *New York*) on one of the pages of the Vorticist sketchbook. The drawing bears a family relationship to this painting, so it is more likely that an extended urban subject lies behind the conception of *Workshop*, rather than the idea of the interior of a studio or workshop, which was first suggested in the catalogue of the John Quinn sale where the painting was titled 'Interior'.

WILLIAM ROBERTS (1895-1980)

107 **Study for Two Step II** 1915

Pencil, watercolour and gouache

11¾ x 9 in

Exhibited: Anthony d'Offay *Abstract Art in England 1913-15* 1969 no 29 (reproduced in colour p 29); Arts Council *Vorticism and its Allies* 1974 no 339 (reproduced in colour p 15); Davis & Long, New York *Vorticism and Abstract Art in the First Machine Age* 1977 no 42 (reproduced); Tate Gallery *Abstraction: Towards a New Art* 1980 no 383 (reproduced)

Literature: William Roberts *8 Cubist Designs* 1969 (pl 2); Richard Cork *Vorticism and Abstract Art in the First Machine Age* 1976 (reproduced in colour p 385)

Roberts joined the Omega Workshops in October-November 1913, and by his own admission was already versed in abstract art. His time at the Omega, until the spring of 1914, enriched this move into abstraction. Unfortunately no work identifiable as being by Roberts survives from the Omega collaboration.

108 **The Dancers** 1919
Oil on canvas
60 x 46 in
Glasgow Art Gallery and Museum
Provenance: Anthony d'Offay
Exhibited: Anthony d'Offay *British Paintings, Drawings and Sculpture 1890-1975* 1975; Arts Council *Vorticism and its Allies* 1974 no 464
Literature: Richard Shone 'Modern English Paintings in London' *The Burlington Magazine* December 1975 fig 61

Rudolph Stulik, the proprietor of the Restaurant de la Tour Eiffel at 1 Percy Street (now the White Tower Restaurant) commissioned decorations from William Roberts and Wyndham Lewis for a private room (Lewis) and the first floor landing (Roberts). In the latter half of 1915, Lewis had painted, possibly directly onto the walls of the first floor room, three abstract paintings. This dining room came to be known as the Vorticist Room, and the landing where Roberts's canvases were hung led directly into it. Thus Roberts's three canvases would have been executed in a sense of competition. We know the subject of two of them, *Dancers* and *Diners* (Tate Gallery), but the third canvas is lost. The sale of the restaurant's contents on January 12, 1938 lists three futuristic painted panels (lot 55) and these may well be Roberts's pictures.

EDWARD WADSWORTH (1899-1949)

109 **Study for Cape of Good Hope** 1914
Ink, crayon, watercolour and gouache
13 x 9⅞ in
Signed with monogram
Exhibited: Arts Council *Vorticism and its Allies* 1974 no 316; Davis &
 Long, New York *Vorticism and Abstract Art in the First Machine Age*
 1977 no 44; Tate Gallery *Abstraction: Towards a New Art* 1980 no 391
Literature: Richard Cork *Vorticism and Abstract Art in the First Machine
 Age* 1976 (reproduced in colour p 367)

Wadsworth's association with the Omega lasted only from the summer
until October 1913, when he left with Lewis.

OMEGA FURNITURE

110 **Three Red Omega Dining Room Chairs** 1913
Painted wood with cane seat and back
Each 43¼ x 20 x 21½ in
Provenance: The Fry Family
Literature: Frances Spalding *Roger Fry, Art and Life* 1980 pl 92; Isabelle
 Anscombe *Omega and After* 1981 pl 20; Judith Collins *The Omega
 Workshops* 1984 (reproduced in colour pl V)

Designed for the Omega Workshops by Roger Fry and made by the Dryad
Company of Leicester. Painted over a gesso ground. Most of the chairs
made for the Omega were coloured a Chinese lacquer red.

111 **Two Red Omega Dining Room Chairs with Omega Symbol** 1913
Painted wood with cane seat and back
51¼ x 20 x 21½ in
Provenance: The Fry Family
Literature: Frances Spalding *Roger Fry, Art and Life* 1980 pl 92

Only three of these chairs were ever made, again by the Dryad Company.
Fry designed them specially for the Omega sitting room at the Ideal Home
Exhibition in October 1913 (see p 15), and then kept them for his own
use, not offering them for sale. The circular device set on the top rail
functioned as an Omega symbol, and thus they were not only splendid
dining chairs but also effective advertisements for the Omega Workshops.
The third chair with an Omega symbol is now in the collection of the
Victoria & Albert Museum.

112 **Omega Screen: Figures with Pail** 1913
Oil on wood
Four panels, each 68¾ x 20 in
The Charleston Trust
Exhibited: Press view of the opening of the Omega Workshops 8 July
 1913; Miller's, Lewes *The Omega Workshops* 1946 no 43; Bluecoat
 Gallery, Liverpool *Duncan Grant, Designer* 1980 no 4
Literature: Q. Bell and S. Chaplin 'The Ideal Home Rumpus' *Apollo*
 October 1964 p 287 (reproduced in colour); Isabelle Anscombe *Omega
 and After* 1981 (reproduced in colour pl 11)

Painted by Duncan Grant. This screen was prominent among the
products on show at 33 Fitzroy Square on the Press day, 8 July 1913, as
contemporary photographs record (see p 14). The design, with two
figures in front of the red tent, carrying a pail full of hot water giving off
steam, is a stylistic harbinger of much that Grant was to paint in the latter
half of 1913.

113 **Omega Lilypond Table** 1913-14
Painted wood
49½ x 31½ x 28½ in
Provenance: Quentin Bell
Literature: Judith Collins *The Omega Workshops* 1984 (reproduced in
 colour pl IV)

Designed by Duncan Grant. Lilypond tables and screens were believed to
be the most popular lines of decorated furniture at the Omega. Grant took

his inspiration from a rectangular pond in Fry's garden at Durbins, which was filled with goldfish and waterlilies. The first appearance of this motif in a painting is in the background of Grant's portrait of Fry's daughter *Pamela* (no 42), painted in the summer of 1911. In the following year, Grant made an oil sketch of the goldfish and the waterlilies alone. With that as a basis, he was able to transform the image into a motif of chromatic richness and decorative complexity, painted with a great sense of bravura on table tops and screen panels. The goldfish lose their natural shape and become distorted as though seen through ruffled water.

114 **Omega Lilypond Screen**　1913-14
Oil on wood
Four panels, each 71¾ x 23¾ in
Private Collection

See note to no 113.

115 **Omega Marquetry Lampstand**　1915
Inlaid wood
45 x 16¼ in
Private Collection

The present owner's father was a close friend of the Stephen family, and knew Vanessa Bell before she was married. This friendship encouraged him to become a patron of the Omega, and when he had a new house built at Campden Hill, Airlie Gardens, London in 1914, he commissioned a large carpet for the entrance hall (now known as the 'Pool of Blood', Victoria & Albert Museum). This lampstand was another unique object especially commissioned from the Omega Workshops.

116 **Omega Giraffe Cupboard**　1915-16
Inlaid wood
84 x 45¼ x 16 in
Literature: 'Modern Furniture' *House and Garden* January 1921 (reproduced); Isabelle Anscombe *Omega and After* 1981 pl 18; Judith Collins *The Omega Workshops* 1984 (reproduced in colour pl VI)

Designed by Roger Fry. Fry chose the theme of the Zoo for his mural for the Borough Polytechnic, and one of the most prominent animals was a giraffe. He used the giraffe again for the decoration of this cupboard.

Since the beginning of the Omega, Fry displayed a liking for designs of birds and animals in opposed pairs (e.g., painted stole with two peacocks, Victoria & Albert Museum). Here a pair of giraffes is set against a richly-faceted background on both cupboard doors, and these are surmounted in a ziggurat of three shelves, completing a broken pediment design in marquetry. It is likely that this cupboard was a unique piece requested by a client. An article on 'Modern Furniture' in *House and Garden,* January 1921 illustrates the cupboard in the home of Lady Tredegar, who may well have commissioned it. The shelves are a reconstruction from the original design (see no 28).

117 **Omega Cupboard** 1916
Painted wood
69¾ x 26¾ x 11¾ in
Victoria & Albert Museum

Painted by Roger Fry. This cupboard was decorated for Mme Lalla Vandervelde, wife of Emile Vandervelde, the Belgian socialist leader. She met Fry because the Omega organised fund-raising concerts for Belgian refugees, and in the autumn of 1916 her Chelsea flat was decorated by the Omega Workshops.

118 **Omega Chest of Drawers** 1916
Painted wood
37¼ x 37 x 17¼ in
Victoria & Albert Museum

Painted by Roger Fry for Mme Lalla Vandervelde (see note to no 117).

119 **Omega Toy Chest** 1916-17
Painted wood
17½ x 37 x 18 in
Provenance: Mrs Beatrice Mayor
Exhibited: Miller's, Lewes *The Omega Workshops* 1946 no 13; Victoria & Albert Museum *Omega Workshops Fiftieth Anniversary Exhibition* 1963 (no catalogue)

Painted by Roger Fry. The decoration of the front, with its still life of fruit in a black bowl, is very close to that of the footboard of a bed which Fry painted for Mme Lalla Vandervelde. (The bed and several pieces of Vandervelde furniture are in the Victoria & Albert Museum.)

120 **Sofa with Omega Upholstery** 1918
Wood frame and woven fabric
28 x 83 x 26 in
Provenance: Roger Fry

Soon after the end of the First World War, Fry wrote to Vanessa Bell that as it was not possible to get furniture made at that time, he was buying old furniture instead to decorate at the Omega (26 December 1918). This sofa was purchased by Fry and then upholstered in *Cracow* Jacquard woven fabric, which had been designed by Roger Fry and produced for the Omega by A H Lee, of Birkenhead, Cheshire. Fry named the fabric after the Battle of Cracow, in 1914.

121 **Pair of Omega Ladderback Chairs** 1918
Painted wood with rush seat
Each 35½ x 18½ x 15½ in

Two rush-seated chairs decorated by the Omega Workshops (see note to no 120).

OMEGA BOXES

122 **Omega Box with Reclining Figure** 1913
Pencil, oil and lacquer on wood
3¼ x 13¼ x 5¼ in
Omega symbol painted on base
Provenance: Duncan Grant

Probably painted by Duncan Grant.

123 **Omega Box with Animals** 1913
Gouache on wood
Height 4¼ in, diameter 8½ in
Omega symbol painted on the side

Probably painted by Henri Gaudier-Brzeska.

124 **Omega Box with Reclining Nude** 1913-14
 Oil and lacquer on wood
 $2\frac{7}{8}$ x $12\frac{1}{2}$ x $4\frac{1}{4}$ in
 Omega symbol painted on base
 Provenance: The Fry Family

 Painted by Duncan Grant. Given to Fry's daughter Pamela for Christmas
 1917.

125 **Omega Box with Abstract Design** 1913-14
 Oil and lacquer on wood
 $3\frac{1}{2}$ x $7\frac{1}{4}$ x 4 in
 Omega symbol painted on back
 Provenance: Naomi Mitchison

126 **Omega Box with Vase of Flowers** 1915-16
 Oil on wood
 $3\frac{1}{8}$ x $6\frac{1}{2}$ x $4\frac{3}{4}$ in
 Omega symbol painted on front
 Provenance: Naomi Mitchison

 Painted by Pamela Diamand

127 **Omega Painted Jewellery Box** 1916-17
 Oil on wood
 4 x 7 x 5 in
 Provenance: The Fry Family

 Painted by Fry to enliven a Victorian box owned by his sister, Joan.

OMEGA TRAYS

128 **Omega Painted Tray: Madonna and Child** 1913
Oil on wood
Diameter 17¾ in
Omega symbol painted on base
Private Collection

Painted by Vanessa Bell at Christmas 1913. The motif of a Madonna and child flanked by kneeling wingless angels is associated with Omega Christmas card designs by Grant, and related to Bell's own pottery figure *Madonna and Child* (136).

129 **Omega Marquetry Elephant Tray** 1913-14
Inlaid wood
Diameter 26½ in
Omega symbol on outside of rim
Provenance: Roger Fry
Exhibited: Bluecoat Gallery, Liverpool *Duncan Grant, Designer* 1980 no 25
Literature: Arts Council *Vorticism and its Allies* 1974 no 129; Richard Cork *Vorticism and Abstract Art in the First Machine Age* 1976 (reproduced p 90); Frances Spalding *Roger Fry, Art and Life* 1980 p 115 (reproduced in photograph of the hall at Durbins); Isabelle Anscombe *Omega and After* 1981 pl 5

Designed by Duncan Grant. When Fry wrote a book on the art of Grant in 1923, he gave his opinion that 'when Grant worked at the Omega some of the designs which he [Grant] made for carpets, for marquetry, and for needlework represent the high-water mark of applied design in England'. This marquetry tray was obviously one of the items Fry had in mind, since he used it as the final plate in his Omega Workshops descriptive illustrated catalogue in 1914. As in the case of Fry's *Giraffe Cupboard* (see nos 28 and 116), Grant produced a *papier collé* design for translation into marquetry, which was passed to the cabinet-maker responsible for all Omega marquetried objects, John Joseph Kallenborn, who had his workshop in Stanhope Street, just across the Euston Road from Fitzroy Square.

130 **Colour Samples of the Six Omega Linens** 1913
25 samples, each 15 x 10 in (approximately)

Six linens were produced by the Omega Workshops and printed by the Maromme Print Works, Rouen, France. They were made in 31 inch widths.

a) **Amenophis**
 Printed linen (five colour schemes)

 Exhibited: Arts Council *Vision and Design* 1966 no 109 (a); Arts Council *Vorticism and its Allies* 1974 no 131 (reproduced)

 Literature: Quentin Bell *Bloomsbury* 1974 (reproduced between pp 48-49); Richard Cork *Vorticism and Abstract Art in the First Machine Age* 1976 (reproduced p 90); Frances Spalding *Roger Fry, Art and Life* 1980 pl 65

 Designed by Roger Fry, and based on *Still Life: Jug and Eggs* 1911 (24). See also no 134.

b) **Margery**
 Printed linen (two colour schemes)
 Literature: Isabelle Anscombe *Omega and After* 1981 pl 9

c) **Maud**
 Printed linen (four colour schemes)

 Exhibited: Arts Council *Vision and Design* 1966 no 109 (d); Arts Council *Vorticism and its Allies* 1974 no 132

 Literature: Richard Cork *Vorticism and Abstract Art in the First Machine Age* 1976 (reproduced p 89)

 Designed by Vanessa Bell (see nos 6, 132, 133).

d) **Mechtilde**
 Printed linen (six colour schemes)
 Exhibited: Arts Council *Vision and Design* 1966 no 109 (b)
 Literature: Richard Shone *Bloomsbury Portraits* 1976 pl 64; Isabelle Anscombe *Omega and After* 1981 pl 10

 Possibly designed by Roger Fry (see no 25).

e) **Pamela**
Printed linen (four colour schemes)
Exhibited: Bluecoat Gallery, Liverpool *Duncan Grant, Designer* 1980
no 8
Literature: Isabelle Anscombe *Omega and After* 1981 pl 11

It has been suggested that *Pamela* was designed by Duncan Grant.
The patches of bold flat colour in this printed linen design share an
affinity with Grant's lilypond designs.

f) **White**
Printed linen (four colour schemes)
Exhibited: Arts Council *Vision and Design* 1966 no 109 (c)
Literature: Richard Shone *Bloomsbury Portraits* 1976 pl 64; Isabelle
Anscombe *Omega and After* 1981 pl 7.

Designed by Vanessa Bell.

131 **Omega Embroidered Chair Cover** 1913
Needlework
17 x 21 in
Provenance: The Fry Family

Designed by Duncan Grant, embroidered by Ethel Grant, the artist's
mother, and given to Pamela Diamand when the Omega Workshops
closed in 1919. Probably for the Omega 'Ideal Nursery'.

132 **Omega Blouse** 1914-15
White linen, with collar and cuffs of *Maud* printed linen
Length 19 in

The Omega Workshops began making this style of blouse in 1914.

133 **Roger Fry's Omega Pyjamas** 1918
Maud printed linen
Jacket length 34 in; trousers 41½ in.
Provenance: The Fry Family
Exhibited: Davis & Long, New York *Vanessa Bell* 1980 no 83

Worn by Roger Fry to a Russian Ballet party in London in 1918.

134 **Omega Dressing Gown** 1918
Amenophis printed linen
Length 54 in
Provenance: The Fry Family

Made by Pamela Diamand

OMEGA POTTERY

Omega pottery began with the artists overpainting commercial plates. But Fry soon realised that this was only a compromise: he had to have control over the shape and feel of the object, as well as its decoration; he learned under the aegis of George Schenck, a potter living in Mitcham, and made almost all the Omega pottery himself. Fry also took lessons at Camberwell School of Art, where he sought advice about various glazes. White tin glaze was his preferred glaze throughout the Omega years. It worked well as a background for decoration – usually an abstract design in two colours, blue and ochre. Fry experimented with many other glazes, and during the time he worked with Schenck, autumn 1913 to autumn 1914, he also used a brown, a turquoise and a bright green glaze. In the autumn of 1914 he met the Carter family, who ran Poole Potteries; attracted by the superior facilities there, he attempted a wider range of shapes. Until that time Omega pottery made by Fry had consisted almost entirely of bowls, vases and jugs; at Poole he made coffee sets, tea sets and dinner services. In 1915 he introduced a dark cobalt blue and grey/blue mottled glaze. In 1916 Fry frequently used a dramatic black glaze; there was also a short-lived experiment with a purple glaze.

All pieces are of earthenware and attributed to Roger Fry except where otherwise specified. The majority come from the Fry Family.

135 **Omega Polar Bear** 1913
White tin glaze $2\frac{7}{8} \times 5$ in
Omega symbol incised on base

136 **Madonna and Child** 1913
White tin glaze overpainted in blue and brown 9 x 4¾ x 7¾ in
Private Collection

Modelled by Vanessa Bell and decorated by Duncan Grant. Vanessa Bell
wrote to Fry about a visit she and Grant had made to George Schenck's
workshop at Mitcham: 'Mr Schenck gave us some clay to bring home and
said if we liked to model some figures he would cast them for us . . . So I
have spent hours today trying to model a figure which . . . is most exciting
. . .'. This piece is the result of that visit. The composition, of a Madonna
and child, relates to Grant's designs for Omega Christmas cards on the
same theme. Grant recalled that he applied the coloured pigments. This
pottery figure also bears a strong resemblance to an Omega tray of the
same date painted by Bell (128).

137 **Omega Pot** 1913-14
White tin glaze height 4 in
Omega symbol incised on base

138 **Omega Pot** 1913-14
White tin glaze height 4 in
Omega symbol incised on base

139 **Omega Bowl** 1913-14
White tin glaze height 4 in
Omega symbol incised on base

140 **Omega Pot** 1913-14
White tin glaze with blue and purple overpainted design
Height 3¼ in
Omega symbol painted on base

141 **Omega Vase** 1913-14
White tin glaze with blue and yellow overpainted design
Height 8¼ in
Omega symbol incised on base

142 **Omega Inkstand** 1913-14
White tin glaze 3⅞ x 8⅜ x 7⅛ in
Omega symbol incised on base

143 **Omega Jar** 1913-14
Green glaze height 5¾ in
Omega symbol incised on base

144 **Plate: Stooping Figure** 1913-14
Off-white glaze with black overpainted design
Diameter: 7 in
Literature: Richard Cork *Vorticism and Abstract Art in the First Machine Age* 1976 (reproduced p 546)

Decorated by Cuthbert Hamilton, but not an Omega object. Possibly made at the Rebel Arts Centre.

145 **Omega Plaque: Mother and Child** *c.* 1914
Painted and glazed diameter 9⅜ in
Omega symbol stamped twice on base

Painted by Duncan Grant. The design is closely related to Grant's Tunisian vase of early 1914 (The Charleston Trust).

146 **Omega Cat** 1914
Green glaze 4⅝ x 4½ x 2½ in
Omega symbol stamped on base
Provenance: R. A. Bevan
Private Collection
Literature: Arts Council *Henri Gaudier-Brzeska* 1956 no 18; Roger Cole *Burning to Speak* Phaidon 1978 (reproduced p 88); Kettle's Yard, Cambridge *Henri Gaudier-Brzeska* 1983 no 45 (reproduced).

This cat was originally modelled in clay by Gaudier-Brzeska, and a two-piece mould was made, from which casts could be produced. The five surviving Omega cats each have different coloured glazes.

147 **Omega Serving Plate** 1914-16
White tin glaze diameter 15½ in
Omega symbol stamped on base
Provenance: Winifred Gill

148 **Two Omega Dinner Plates** 1914-16
White tin glaze diameter 12 in
Omega symbol stamped on base

149 **Eight Omega Soup Plates** 1914-16
White tin glaze diameter 11¼ in
Omega symbol stamped on base

150 **Four Omega Dessert Plates** 1914-16
a-b Black glaze c-d White tin glaze
Diameter 9¾ in
Omega symbol stamped on base

151 **Two Omega Vegetable Dishes** *c.* 1915
White tin glaze diameter a 9in, b 9¼ in
Omega symbol incised on base

152 **Omega Plate: Vase of Flowers** 1914-15
White tin glaze with red, blue, yellow and green overpainted design
Diameter 9¾ in
Omega symbol stamped on base

This plate was made by Fry and decorated, probably by Vanessa Bell,
at the Omega Workshops.

153 **Omega Jug** 1914-15
White tin glaze with yellow and blue overpainted design
Height 10 in

154 **Omega Vase** 1914-15
Blue glaze height 5½ in
Omega symbol incised on base

155 **Omega Pot with Lid** 1914-15
Blue glaze height 4¾ in
Omega symbol incised on base

156 **Omega Pot** 1915-16
Green glaze height 5½ in
Omega symbol incised on base

157 **Omega Vase** 1915-16
White tin glaze with blue overpainted design
Height 7 in
Omega symbol painted on base

158 **Omega Fruit Stand** 1916-18
Black glaze height 3¾ in
Omega symbol incised on base
Provenance: Winifred Gill

159 **Omega Vase** 1916-18
Black glaze height 5⅞ in
Omega symbol incised on base
Provenance: Winifred Gill

160 **Omega Milk Jug** 1916-18
Black glaze height 4⅛ in
Omega symbol incised on base
Provenance: Winifred Gill
Literature: Judith Collins *The Omega Workshops* 1984 pl 95

Designed by Fry for the Omega tea and coffee service.

161 **Omega Jam Pot** 1916-18
Blue glaze height 5⅜ in
Omega symbol incised on base
Literature: Judith Collins *The Omega Workshops* 1984 pl 95

Designed by Fry for the Omega tea service.

162 **Two Omega Side Plates** 1916-18
a White tin glaze, b blue glaze diameter 7⅝ in
Omega symbol stamped on base

163 **Omega Fruit Bowl** 1917-18
Blue glaze diameter 8⅛ in
Omega symbol incised on base

Given to Pamela Diamand by her father, Roger Fry.

DATE DUE

GAYLORD			PRINTED IN U.S.A.